Major Themes in
Japanese Art

Volume 1

THE HEIBONSHA SURVEY OF JAPANESE ART

For a list of the entire series see end of book

CONSULTING EDITORS

Katsuichiro Kamei, *art critic*
Seiichiro Takahashi, *Chairman, Japan Art Academy*
Ichimatsu Tanaka, *Chairman, Cultural Properties Protection Commission*

Major Themes in Japanese Art

by ITSUJI YOSHIKAWA

translated by Armins Nikovskis

New York · WEATHERHILL/HEIBONSHA · Tokyo

This book was originally published in Japanese by Heibonsha under the title *Nihon Bijutsu Nyumon* in the Nihon no Bijutsu series.

A full glossary-index covering the entire series will be published when the series is complete.

First English Edition, 1976

Jointly published by John Weatherhill, Inc., 149 Madison Avenue, New York, New York 10016, with editorial offices at 7-6-13 Roppongi, Minato-ku, Tokyo 106, and Heibonsha, Tokyo. Copyright © 1966, 1976, by Heibonsha; all rights reserved. Printed in Japan.

Library of Congress Cataloging in Publication Data: Yoshikawa, Itsuji. / Major themes in Japanese art. / (The Heibonsha survey of Japanese art; v. 1) / Translation of Nihon bijutsu nyūmon. / 1. Art, Japanese—History. I. Title. II. Series. / N7350.Y6313 / 709′.52 / 75-22368 / ISBN 0-8348-1003-4

Contents

Major Themes in
Japanese Art

Primitive Art in Japan

THIS BOOK IS AN OVERVIEW not simply of the major themes of Japanese art but of Japanese art seen within the framework of the main currents of world art history as a whole. Each aspect of Japanese art is related to dominant themes in other traditions in terms of their correspondences with and influence on the development of major modes of expression in the arts of Japan.

Most of the volumes in the Heibonsha Survey of Japanese Art have very naturally emphasized the important role played in the development of Japanese art by the art of China, especially that of the Six Dynasties, Sui, and T'ang periods—a span of time stretching from the third to the tenth century. However, I have eschewed this approach in order to focus on a more neglected but nonetheless significant sphere of influence: the classical tradition of Greek and Roman art and the art of Parthian and Sassanian Persia as reflected in the arts of Japan. In this I follow the precedent set by my mentor, the art historian Yukio Yashiro, who was among the first scholars in the field to consider Japanese are history within the larger context of *world* art history.

Although I have emphasized the role of Greek, Roman, and Iranian themes, needless to say these did not influence Japanese art directly but were first assimilated into Chinese art, later to appear in the arts of Japan in Sinicized form. I wish especially to underscore the point that Japan, via China, has not mechanically reproduced these themes but has absorbed and reflected in its art their universal aspects.

Because of this approach to the subject as well as limitations of space, I have tried not to rehash information that is to be found in other volumes of this series. In particular, the discussion of Japanese art following the Kamakura period (1185–1336) has been abbreviated to its most essential elements in order to permit a fuller discussion of the major themes of the formative centuries of Japanese art. For detailed treatments of the various periods and genres of Japanese art the reader is urged to consult the appropriate volumes in the series, many of whose authors are cited in the following pages.

THE JOMON AND YAYOI CULTURES The Japanese people as they are known today have probably inhabited the Japanese archipelago for the past twenty-five hundred years. Actually, however, Japan has been settled for at least five thousand years, the earliest known inhabitants being the Jomon people, so named because of their remarkable pottery, which is decorated with what appear to be *jomon*, or cord, patterns. They were basically a mobile hunting-gathering people and lived mainly in the east-central and northeastern parts of Japan. It is not known where these people originated, but they may be related to the modern Ainu, the Caucasoid minority of Hokkaido, the northernmost of Japan's four main islands, and the Kuril island chain

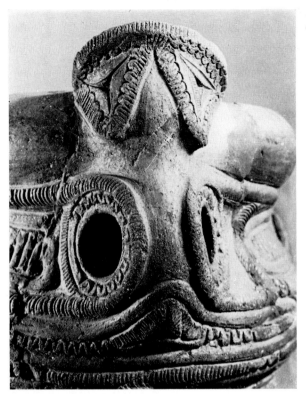

1. *Pot with decoration of mouselike face. Height, 47 cm. Middle Jomon period. Tokuri site, Fujimi, Nagano Prefecture. Togariishi Archaeological Museum, Chino, Nagano Prefecture.*

2. *Deep pot with high-relief whorl-design ears. Height, 43 cm.* ▷ *Middle Jomon period. Sori site, Fujimi, Nagano Prefecture. Idojiri Archaeological Museum, Fujimi, Nagano Prefecture.*

and Sakhalin farther to the north (both part of the Soviet Union). Jomon pottery is among the oldest extant in the world and is remarkable for its beauty and originality. The pieces appeal to the modern man perhaps because of their seemingly contemporary expressionistic, surrealistic, and abstract motifs and shapes.

The arrival of an agrarian people from the Asian continent marks the beginning of a totally new culture known as Yayoi (named after the location where the first remains of the civilization were found). The Yayoi culture, which was based on agriculture rather than hunting and gathering, flourished between 200 B.C. and A.D. 200. Yayoi people are said to have first settled on the island of Kyushu, in southwest Japan, and then moved to central Japan. Only later did they spread to the Jomon area in the north. This culture produced bronze spears, swords, and other objects of metal

and stone, as well as a totally different type of pottery from that of the Jomon culture. The social, cultural, and economic characteristics of the Yayoi people seem to be consistent with those of the Japanese of the historical period (from the sixth century onward), and thus the Japanese people are traced to the Yayoi period.

Jomon art contrasts so remarkably with that of the subsequent Yayoi period that we have the impression that the two cultures were almost diametrically opposed. It is even difficult to conceive that both arts are products of the same country. The differences between a mobile hunting-gathering people and an immobile agrarian people are reflected in the production of pottery of the respective cultures, particularly in the ornamentation.

Jomon culture appears to be related to the Stone Age cultures of the northeastern part of the Asian continent, to Siberia and even northeastern Eur-

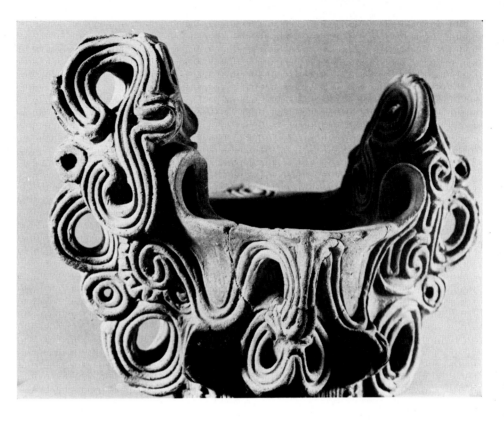

asia, while Yayoi culture is associated with the introduction of wet-rice cultivation, which apparently spread from southeastern Asia and southeastern China via southern China and southern Korea, both of which are known to have utilized metal and stone implements. These differences are extremely interesting, for they suggest the complexities of the cultures behind the Jomon and Yayoi artifacts. It is intriguing indeed to speculate on how Japan would have developed had its heritage followed from the Jomon rather than the Yayoi people.

THE VARIETY OF JOMON DECORATION The earthenware vessels from the Middle Jomon period (around 500 B.C.) found in central Honshu, Japan's major island, bear elaborate ornamentation. These pieces, discovered in and around modern Yamanashi, Nagano, and Niigata prefectures and in the Kanto plain, all in north-central Japan, contain what appear to be designs made by cord impressions. These unique decorative pieces are characterized by extravagant, swelling curves (Fig. 2).

When compared with the rich, complex, yet straight and orderly lines of the *t'ao-t'ieh* monster mask, *hui-lung* dragon, and *lei-wen* (Chinese meander) motifs seen on the bronzes and white pottery of the roughly contemporaneous Shang and Chou periods (c. 1500–221 B.C.) in China, the pottery of the Jomon period appears simple and lacking in any suggestion of belief in a transcendental power. But the pots they made did enable the Jomon people to give free and direct expression to their vibrant energy. Their works, because of the great irregularity of form, exhibit an exceptional variety (Fig. 3). They are compositions not just of abstract curves but of familiar designs, as well. Objects

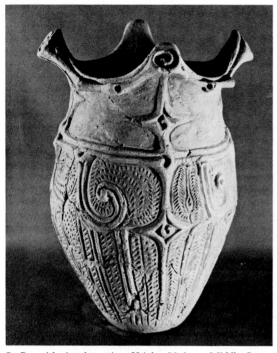

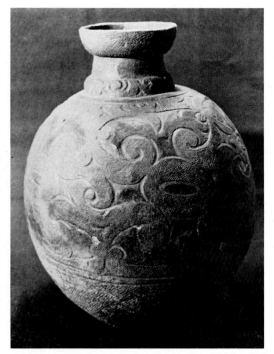

3. *Pot with vine decoration. Height, 31.4 cm. Middle Jomon period. Madaka site, Nagaoka, Niigata Prefecture. Nagaoka Municipal Science Museum.*

4. *Large painted jar with* c-*motif decoration. Height, 41.3 cm. Terminal Jomon period. Kawahara site, Towada, Aomori Prefecture. Hakamada Collection, Aomori Prefecture.*

familiar to the people in their daily lives, such as vines and rough ropes, woven fabrics and mats, were used to impress designs onto the ceramics as decoration.

The mouth of the pot shown in Figure 1 is in the form of a mouselike face, similar to the anthropomorphic or animallike *dogu* (earthenware figurines) that the Late Jomon people produced in abundance. Both the pots and the *dogu* show a wide variety of shapes and decoration, and this may be due to the multifarious nature of the scattered Jomon settlements, which had absorbed a number of different regional strains.

The outstanding feature of Jomon art is its abstract decorative designs. The rhythms created by the curved lines of these decorations are the rhythms of all nature, reflecting man's coexistence with animals and plants and his sharing in the primordial life of the world. The basic unit of the Jomon pattern system is what might be called the *c* motif. This motif, perhaps derived from the shape of animal fangs, is manifested in a simple form in the *magatama* (literally, "curved jewel") ritual ornament. Two such *c*'s combine to form an *x* or an *s;* linked in a continuous line, they form either a flowing water or wave pattern. If the slight inward curve of the upper end of the *c* is elaborated, a spiral is created. In this fashion the basic motif undergoes growth and change to produce a multitude of patterns, rather like the multiplication of an organism's cells or the proliferation of a vine. For primitive people, creating and appreciating such patterns must have been both a mental and a physical exercise, a sort of dialectic of ornament (see Foldout 1).

The pot in Figure 4 has surface decoration con-

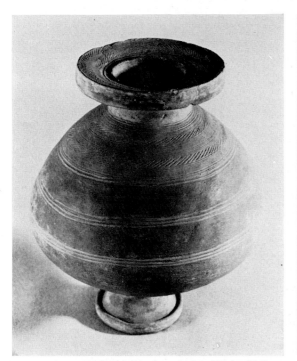 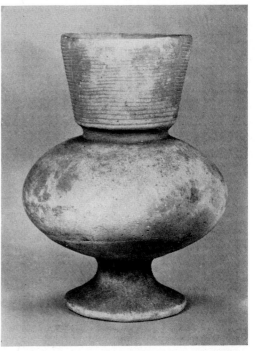

5. Cinnabar-painted, footed earthenware jar. Height, 24.3 cm. Middle Yayoi period. Takakura site, Nagoya, Aichi Prefecture. Tokyo National Museum.

6. Footed earthenware pot. Height, 18 cm. Late Yayoi period. Chiharagasaki site, Toyama, Toyama Prefecture. Tokyo National Museum.

sisting wholly of c motifs. Similarly, the entire surface of the so-called snow-goggle figurine in Figure 7 is covered with a configuration of double-c motifs. Both are excellent examples of the use of these basic units for surface decoration. In addition to this, Jomon motifs often provided the basic forms of which the *dogu* were constructed (Figs. 8–10; Foldout 1). The human figure is built up from combinations of abstract forms rather than naturalistically. The heart-faced *dogu* in Figure 9 is a good example of this technique, although its fully developed form would seem to indicate that several stages of development must have preceded this. In contrast to the face, formed by two facing c shapes, the narrow trunk consists of two c's placed back to back to form an x. From the top of the trunk, arms in the form of small c's hang down to left and right, while large c's attached to the bottom of the trunk form the

figure's legs. On the shoulders, chest, and knees of this peculiar figure are inscribed spiral patterns. The same basic shape, made up of x's and c's, can be seen in the snow-goggle figurine (Fig. 7) and the so-called owl-faced figurine (Fig. 10). Even the somewhat more naturalistic human figure with triangular head (Fig. 8), and others with dot ornamentation, derive their peculiar arms and legs from the same prototype.

The heart-shaped face is a form frequently found in African woodcarvings and masks. When a human face is carved from a curved piece of wood, the left and right sides of the face are whittled away, leaving eyes, nose, and mouth protruding in the middle. The lower section of the wood is narrowed to form the chin, and the top—corresponding to the forehead—is left broad, resulting naturally in a face that is roughly heart shaped. The character-

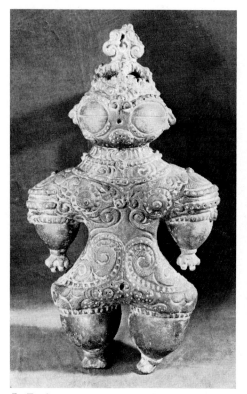

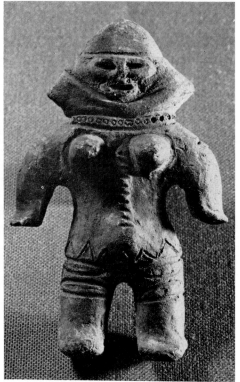

7. *Earthenware figure with snow-goggle eyes. Height, 36 cm. Terminal Jomon period. Ebisudakakoi site, Tajiri, Miyagi Prefecture. Tohoku University, Sendai.*

8. *Earthenware figurine of woman with triangular head. Height, 12.5 cm. Late Jomon period. Shiizuka shell mound, Edosaki, Ibaraki Prefecture. Osaka Municipal Art Museum.*

istic details of the heart-shaped faces of certain Jomon *dogu* are most easily comprehended if we imagine a carved wooden prototype. In the case of the owl-faced figurine, for example, the small circles of the eyes, mouth, and ears and the elaborately applied ornamentation seem to echo woodcarving techniques. The irregular wave shapes around the head can be considered a direct representation of hair, but may also have been suggested to the makers of the *dogu* by the straw or leaf ornaments attached to wooden festival masks to represent hair.

A carved-wood prototype may also account for the strongly protruding eyes of all Jomon figurines. These *dogu* offer us a glimpse of the fertility ceremonies and other collective rites of Jomon society. Primitive man's fear of the unknown and the supernatural is seen in the magical quality of his artifacts.

YAYOI-PERIOD ART Around the third and second centuries B.C., a new mode of life based on primitive agriculture

9. *Earthenware figurine with heart-shaped face. Height, 31 cm. Late Jomon period. Gohara site, Agatsuma, Gumma Prefecture.* ▷
Yamazaki Collection, Gumma Prefecture.

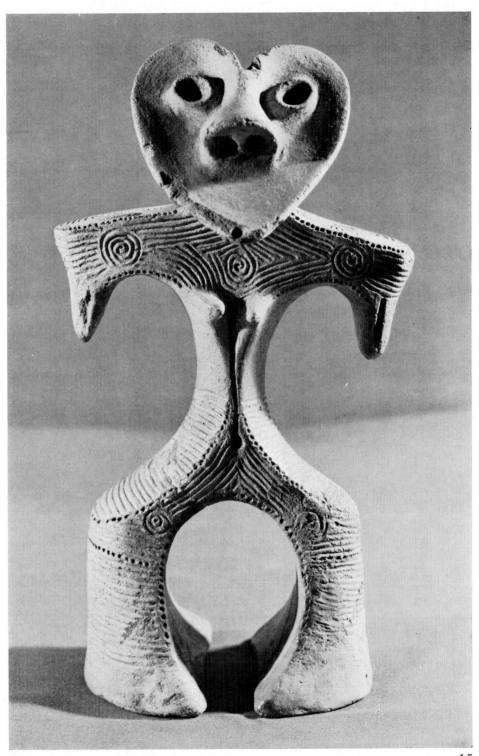

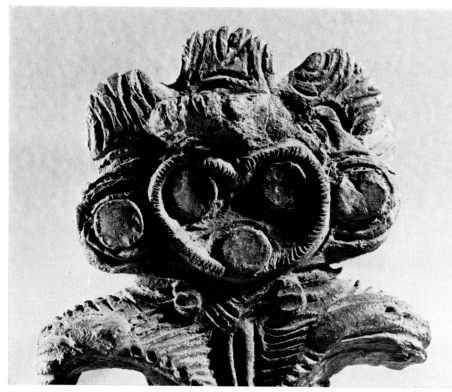

10. Owl-faced painted earthenware figurine. Height, 20.2 cm. Late Jomon period. Shimpuku-ji shell mound, Iwatsuki, Saitama Prefecture. Nakazawa Collection, Tokyo.

spread from west to central Japan. A new type of pottery was made, as well as bronze spears, swords, and *dotaku* (bell-shaped bronzes; Figs. 16–18). Relations with the continent grew closer, and the highly prized bronze mirrors hitherto imported from China began to be made in Japan. Out of many small settlements, strong clans appear to have formed gradually in the areas of Kinai (the Osaka, Nara, and Kyoto vicinity), northern Kyushu, and other parts of western Japan. Eventually, one such unit established hegemony over the Kinai region, forming the first unified Japanese state. The Tumulus-period culture, named for the large tombs constructed by the emerging aristocracy, which inherited and further developed the Yayoi arts from the third to the seventh century, reflects the

process by which local clans gathered around the ruling clan to form an organized state. It may be said that the true foundations of Japanese art as of the Japanese state were laid down in the Yayoi and Tumulus periods.

The earthenware vessels of the Yayoi period were jars of smooth, regular geometric shapes incised with correspondingly simple sawtooth or wave decorations (Figs. 5, 6), in complete contrast to the great variety of shapes and powerful curved patterns of Jomon pots. The bodies of Yayoi pots have simple, balanced shapes that are beautiful in themselves. Their shapes and ornamentation reveal an attitude totally different from that which inspired the Jomon pots, and it is clear that one of the fundamental characteristics of Japanese art of

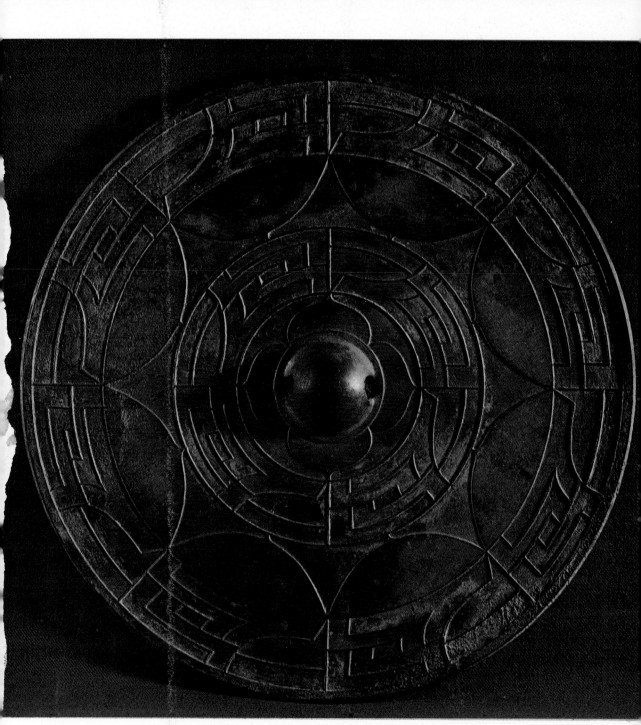

11. Bronze mirror decorated with chokkomon *pattern. Diameter, 28 cm. Fourth century. Niiyama Tomb, Koryo, Nara Prefecture. Imperial Household Agency.*

12 (overleaf). Tomb of Emperor Nintoku. Length of central mound, 475 m. Fifth century. Sakai, Osaka Prefecture. ▷

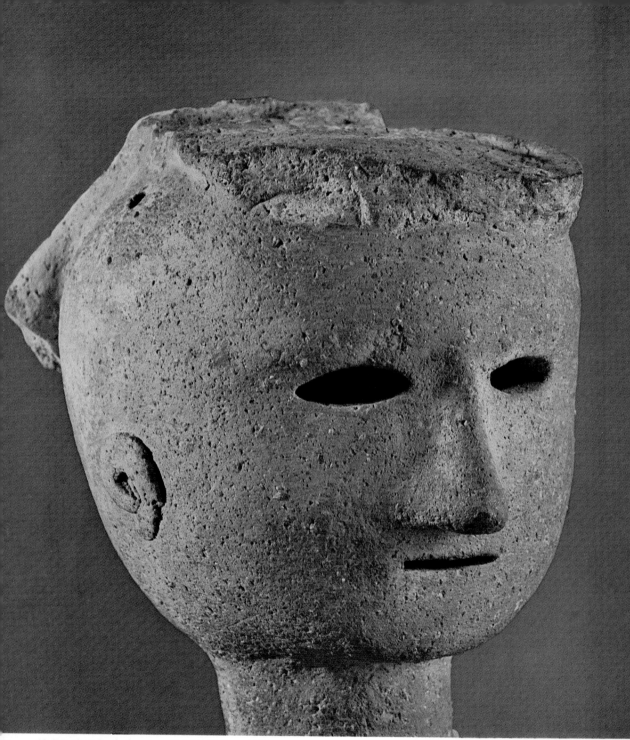

13. **Haniwa** *head of woman. Height, 16.5 cm. Fifth or sixth century. Ichinomoto, Tenri, Nara Prefecture. Matsubara Collection, Tokyo.*

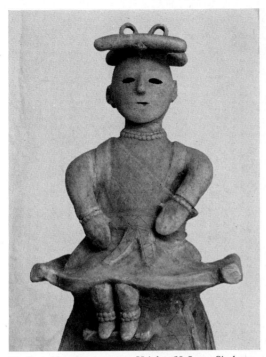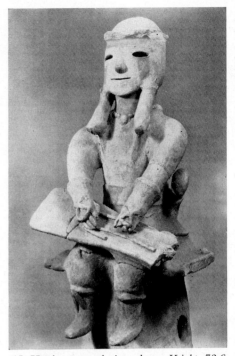

14. *Seated* haniwa *woman. Height, 68.5 cm. Sixth century. Oizumi site, Ora, Gumma Prefecture. Tokyo National Museum.*

15. Haniwa *man playing a* koto. *Height, 72.6 cm. Seventh century. Asakura site, Maebashi, Gumma Prefecture. Aikawa Archaeological Museum, Gumma Prefecture.*

the geometrical type, which is found from this time through the Tumulus period, had already been established.

In both the pottery and the bronze spears and *dotaku,* plain surfaces seem to have been preferred. The impractical size and weight of the *dotaku* and spears indicate that they were ornamental pieces made with no intention other than use in sacred rituals, as symbols of peace and the ruling power. The large, flat body of the *dotaku* with its sharp flanges projecting to left and right forms a slim mountainlike shape. The body bears a kind of lattice pattern of fine, regular lines, and the flanges and bottom edge of the decoration are ornamented with sawtooth, spiral, and flowing-water motifs (Figs. 16, 17).

But the shapes and ornamental patterns of Yayoi art definitely lack the awesome power of those of Jomon objects. They have lost their furious magical properties; they have been tamed by man and are no longer a source of blind fear or dark wonder. Their regular rhythms instead turn the feelings of viewers toward worship of harvest gods or contemplation of order. If Jomon art is an art of blind passion, Yayoi art is one of budding intellect. Just as the historical role of the Yayoi and Tumulus cultures in general was to wipe out the primitive nature of Jomon life and develop a peaceful society in which morality prevailed, so it was the role of Yayoi art in particular to dispel the Jomon image of man as possessed by monstrous beings with the heads of beasts or by the magic spell of the double-*c* motif.

With the dominance of geometrical patterns, representations of the human figure seem to have disappeared for a time, not to reappear until the

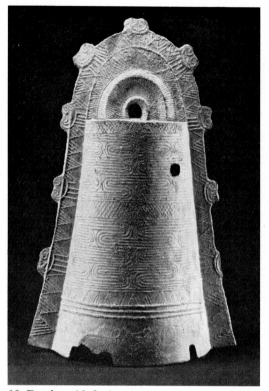

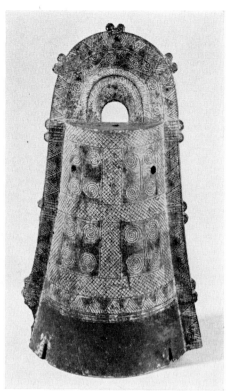

16. Dotaku *with flowing-water pattern. Bronze; height, 60 cm. Late Yayoi period. Tatsuma Collection, Hyogo Prefecture.*

17. Dotaku *with sawtooth, lattice, and spiral motifs. Bronze; height, 47.5 cm. Late Yayoi period. Uzumori site, Kobe, Hyogo Prefecture. Tokyo National Museum.*

advent of *haniwa,* terra-cotta figurines that decorated the burial mounds of the fifth or sixth century. The archaeologist Yukio Kobayashi* has pointed out, however, that pots, *dotaku,* and bronze mirrors do depict, admittedly in crude and primitive line representation, human figures, animals, and everyday utensils (Fig. 18). In a society that was yet to develop a script, these simple images were used to express ideas. After being governed by the requirements of magic for centuries, the makers of these pots and bronzes were free to express their ideas. They may be likened to primitive poets liberating

their vocabulary from the restrictions of purely magical incantation. A new decorative style was formed with geometric patterns as its main element. Until the middle of the sixth century, triangles, diamonds, circles, and spirals, arranged in straight rows or grids, decorated the surfaces of buildings and utentils. The development of such patterns attests a burgeoning self-consciousness and rationalism among artisans as well as a growing confidence in their ability to cover the surfaces of objects with patterns.

TUMULUS-PERIOD ART What began in the Tumulus period (third to seventh century) as a round burial mound with a rectangular projection developed into a neat,

* The names of all modern (post-1868) Japanese in this book are given, as in this case, in Western style (surname last); those of all premodern Japanese are given in Japanese style (surname first).

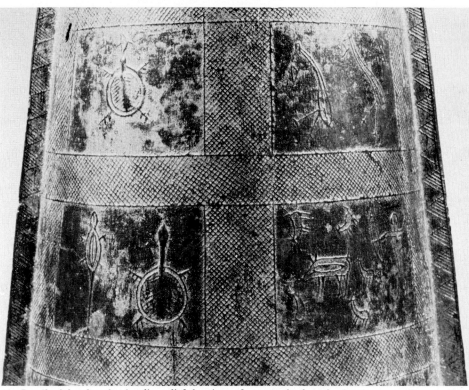

18. Detail of dotaku *showing line-relief drawings of water animals and a hunting scene. Bronze; height, 42.5 cm. Late Yayoi period. Kagawa Prefecture. Ohashi Collection, Tokyo.*

well-proportioned, somewhat flattened shape and eventually became the so-called keyhole tumulus characteristic of ancient Japan.

The culmination of the development of these monuments dedicated to powerful leaders was reached with the construction of the massive tombs of the emperors Ojin (r. 270–310) and Nintoku (r. 313–99; Fig. 12, Foldout 1). Their size reflects the elevated status of the rulers buried therein and the grandeur of their feats. The existence of these tumuli has led scholars to speculate that cultivation of the plains in the Kinai region must have been taking place on a large scale at the time. Provisions for flood control and irrigation serve as evidence of the extensive organization of agriculture in the area. Likewise, the huge tombs with their surround-

ing moats are proof of great technological advances. The overall form of the tombs, combining a circular mound with a trapezoidal mound and surrounding both with a series of moats, is the ultimate expression of the Yayoi tendency toward balanced geometric design.

Found on the tumuli are terra-cotta objects known as *haniwa*. Originally cylindrical in form, they include representations of human beings, animals, dwellings, and weapons and other implements. Only a few examples of the excellent early *haniwa* of human figures found in the Kinai region are extant (Fig. 13). Most of the extant human *haniwa* are later ones from the distant Kyushu and Kanto areas (the present-day Tokyo region). Those from north Kanto (Figs. 14, 15) illustrate an espe-

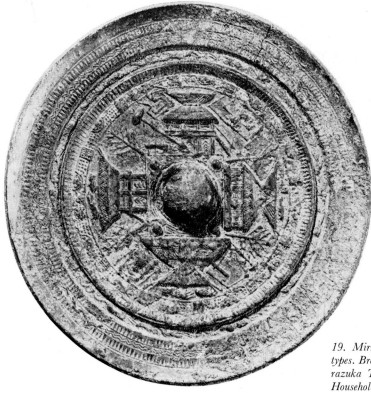

19. *Mirror showing prehistoric dwellings of various types. Bronze; diameter, 23 cm. Fourth century. Takarazuka Tumulus, Samida, Nara Prefecture. Imperial Household Agency.*

cially wide variety of daily activities of the people of the time. The modern quality of their open expressions causes us to forget the fifteen hundred years that separate them from our own age. They are fascinating for what they tell us of the simple and direct attitude toward human beings held by the Japanese before the introduction of Buddhist sculpture from the continent. Some of the facial expressions that distinguish the sculpture of the later Asuka (552–646) and Hakuho (646–710) periods can already be discerned in the *haniwa*.

A pattern that is peculiar to Japan, the *chokkomon* (literally, "arc-and-straight-line pattern"), first appeared in the Tumulus period. Comprised of arcs and straight lines made with compass and rule, this unique motif may have developed from a stylization of magical knotted cords (*musubi-himo*), and is thought to symbolize the ideals of purity,

goodness, and peace. Because one of the most perfect representations of these ideals is found on a fourth-century bronze mirror with a *chokkomon* design on the back (Fig. 11), this mirror is ideally suited to be the spiritual symbol of Japan. This superbly preserved treasure carries with it the spiritual power of the gods and seems to express the confidence of the Japanese people of the time in a direct connection between the world of the gods and the world of man.

Among the later tumuli in Kyushu, many have a sarcophagus chamber with colorfully painted stone walls. Here the primary design motifs are triangles, diamonds, concentric circles, and other geometric forms. A lively atmosphere was created within the chamber by painting *chokkomon*, scroll, and spiral designs on the walls in bright red, yellow, green, and black pigments. Representations of

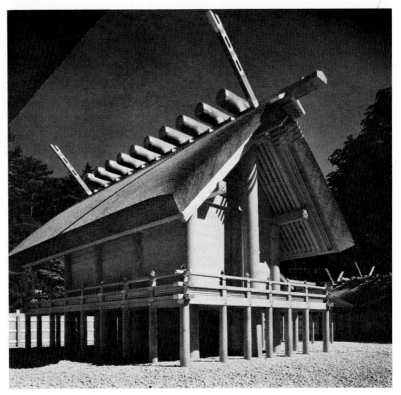

20. Shoden *(main sanctuary)* of the *Inner Shrine (Naiku) of Ise Shrine. Mie Prefecture.*

human beings, horses, and such objects as weapons and boats have also been found, offering us a glimpse of the daily life of the warriors of those times. The chamber of the Otsuka Tumulus (Fig. 21) has a ceiling painted a purplish red, with small round yellow spots that apparently represent stars. The atmosphere of the chamber is intensified by the brightly colored small triangular shapes that cover the back wall.

SHRINE ARCHITECTURE Finally, the Tumulus period saw the establishment of sacred precincts for the gods, which were to become the sites of festivals connected with the seasons and the position of the sun—rituals that naturally dominated the life of an agricultural people. It was also at this time that the prototypes of all later shrine architecture in Japan were estab-

lished. The buildings depicted on the mirror (Fig. 19) excavated from the Takarazuka Tumulus and *haniwa* in the form of buildings appear to represent not only the houses of rulers and nobles but also the dwellings of the gods.

According to the historian Yasutada Watanabe, the two main types of ancient shrine architecture are represented by the Inner Shrine (Naiku) at Ise, Mie Prefecture (Fig. 20), and the Great Shrine at Izumo, Shimane Prefecture. The former had as its prototype the raised-floor granary or treasury type of structure shown on the top of the mirror in Figure 19, while the latter was based on a more or less square form of dwelling built around a central post and with an entrance at one of the gable ends. The perfected forms of the two shrines as we know them today date from the reign of Emperor Temmu (r. 673–86), when the practice of dismantling and

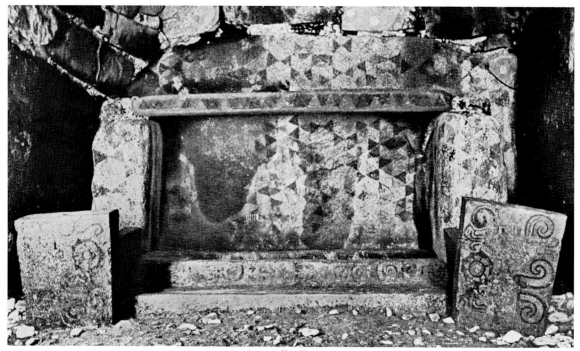

21. Stone tomb chamber with geometric patterns painted on walls. Sixth century. Otsuka Tumulus, Keisen, Fukuoka Prefecture.

completely rebuilding the Ise shrines at regular intervals of twenty years was established. At the same time the original Yakushi-ji temple in Nara was built, and the reconstruction of the Horyu-ji temple near Nara was under way following its destruction by fire. All this architectural activity would seem to be one manifestation of the upsurge of Japanese historical awareness that took place during the Hakuho period, discussed in detail in chapter 2.

Shrine architecture, particularly that of Ise, is a distillation of the aesthetic ideals of the Yayoi and Tumulus periods. As the German architect Bruno Taut has pointed out, it is here that we find the essence of the Japanese sense of beauty. Is there another wooden building anywhere that exhibits such geometric balance, radiating so powerful a feeling of the spirituality of pure form? In order to evoke the divine spirits, everything is reduced to its essence: every pillar, every board is refined to an immaculate beauty. And this pure geometry of wood, unlike that of stone, is the harmony of the divine forest—ever fresh, undefiled, unperishing, and self-renewing.

Early Classical Art:
The Nara Period

THE INTRODUCTION OF BUDDHISM to Japan in the middle of the sixth century was an event of enormous significance not only for Japanese art but for society as a whole. In the train of the new religion came the entire range of Chinese culture. In transplanting this highly advanced civilization to native soil, the Japanese people embarked on a program of "modernization."

Early Japanese Buddhist art was modeled on the art of the Chinese Six Dynasties period (222–589) and that of the Sui (589–618) and T'ang (618–907) dynasties, which arrived first via the Korean peninsula and later directly from China itself. The great Chinese religious art of these periods had been influenced not only by Indian art but also by the art of Iran and Central Asia, and these in turn had been affected by the classical tradition of ancient Greek art. During the Nara period (646–794), named for Japan's first permanent capital, it was the task of Japanese artists to study faithfully the disciplines of Sui and T'ang art, and through this training they mastered the Chinese classical tradition of humanism in both art and letters. Just as in architecture, where a characteristically Japanese style soon emerged, so too in the sculpture, painting, and applied arts of the Nara period a native tradition and classical style were created based on Sui and T'ang models. Henceforth, when-

ever a classical movement arose in Japanese art, the model returned to was the art of the Nara period.

ASUKA SCULPTURE It is recorded that Shiba Tatto, a Chinese immigrant artisan in Japan, prayed to a Buddhist statue at his home in the year 522. This suggests that statues of the buddhas were at first objects of veneration by naturalized aliens. It is also written that in either 538 or 552 King Song Myong (Shomyo in Japanese) of the Korean kingdom of Paekche sent a gilt-bronze image of Sakyamuni Buddha to Emperor Kimmei of Japan, together with Buddhist sutras and other ritual objects. During the reign of Emperor Bidatsu (r. 572–85) more Buddhist images and sutras arrived in Japan, accompanied by groups of monks and nuns sent from Paekche and Silla.

Soga no Umako (d. 626), one of the most powerful figures at the Japanese court, built a Buddhist sanctuary and a pagoda on his private estate; but opposition to the foreign religion from the court factions of the indigenous Shinto religion was so violent that these structures were destroyed by a group led by Mononobe no Moriya. Nevertheless, the spreading acceptance of Buddhism at the court is suggested by the fact that the next emperor,

22. *View of present-day Asuka.*

Yomei (r. 585–87), intended to convert to Buddhism before his untimely death. Eventually Umako and the pro-Buddhist faction prevailed over the rival Mononobe clan. During the reign of Emperor Sushun (r. 587–92), Paekche sent reliquaries, monks, and temple architects, painters, tilemakers, and other artisans to Japan, and construction of the Hoko-ji temple at Asuka was begun. The temple buildings were completed in 596, during the reign of Empress Suiko (592–628), and ten years later a 16-foot-high statue of Shaka (Sakyamuni) Buddha made by Tori Busshi, grandson of Shiba Tatto, was installed in the Middle Golden Hall of the temple.

Although the Hoko-ji was built by Soga no Umako, its construction was virtually a state enterprise, since the power of the Soga clan was greater even than that of the imperial house, and the Soga dominated the financial and military affairs of the court. The temple's ground plan (Fig. 23), ascertained by excavations, is truly grand in conception. A central pagoda was flanked by three *kondo* to the north, east, and west. The whole compound was surrounded by a cloister with a gate in the center of the south wall. This magnificent cluster of buildings differs from the simple arrangement of buildings at the Shitenno-ji in Osaka (Fig. 23), where the gate, pagoda, and *kondo* are simply aligned along the north-south axis of the temple in the layout generally considered representative of Asuka temple architecture. The clustered arrangement at the Hoko-ji reveals that from the start Umako intended to build a perfect temple, in no way inferior to those on the Korean peninsula. The same arrangement of structures can be seen in temple remains at Ch'ongamri in what was the Korean kingdom of Koguryo, and the fact that the builders of the Hoko-ji emulated such models is

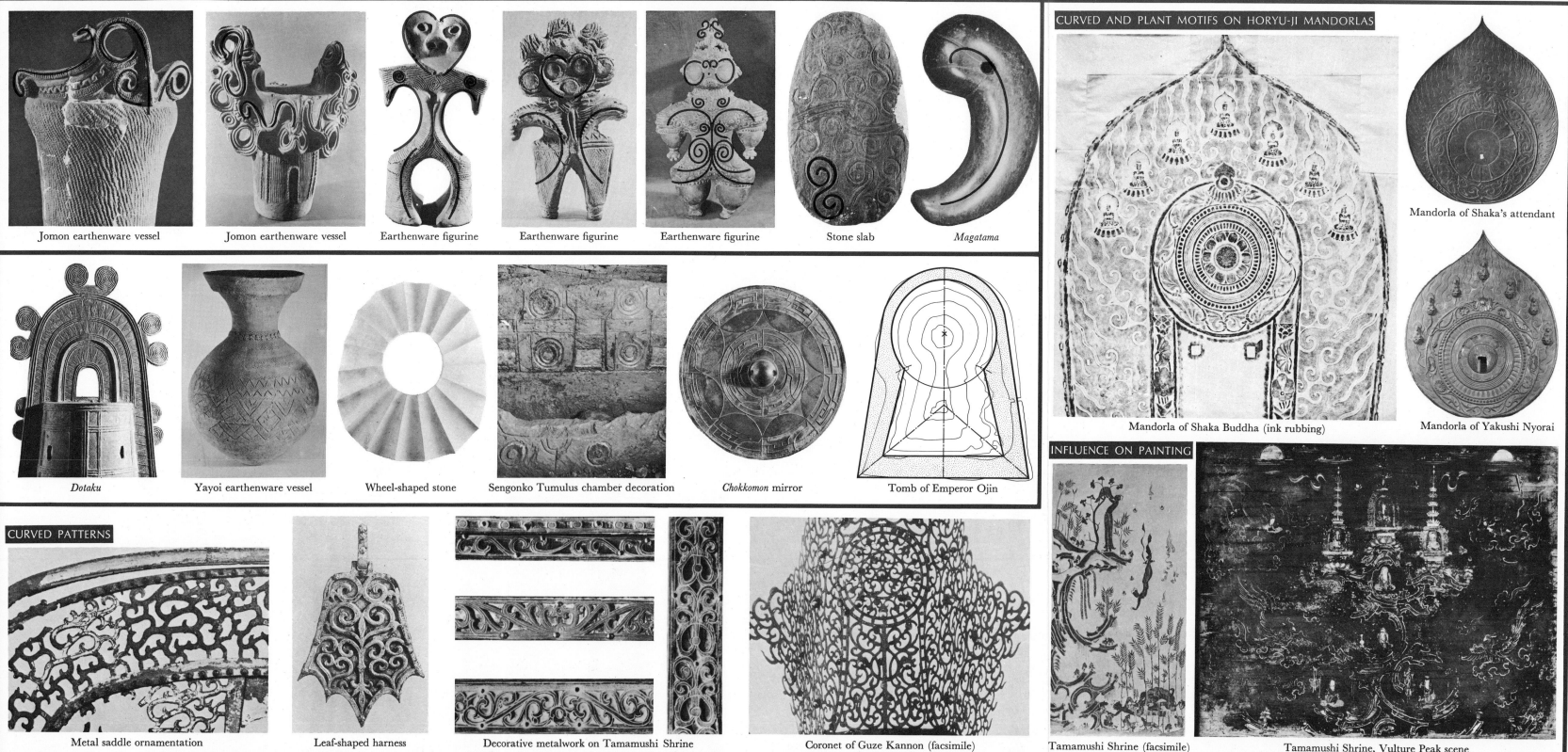

Jomon earthenware vessel

Jomon earthenware vessel

Earthenware figurine

Earthenware figurine

Earthenware figurine

Stone slab

Magatama

Dotaku

Yayoi earthenware vessel

Wheel-shaped stone

Sengonko Tumulus chamber decoration

Chokkomon mirror

Tomb of Emperor Ojin

CURVED AND PLANT MOTIFS ON HORYU-JI MANDORLAS

Mandorla of Shaka's attendant

Mandorla of Shaka Buddha (ink rubbing)

Mandorla of Yakushi Nyorai

INFLUENCE ON PAINTING

CURVED PATTERNS

Metal saddle ornamentation

Leaf-shaped harness

Decorative metalwork on Tamamushi Shrine

Coronet of Guze Kannon (facsimile)

Tamamushi Shrine (facsimile)

Tamamushi Shrine, Vulture Peak scene

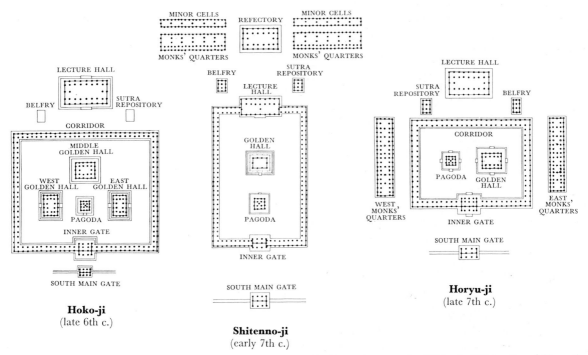

MINOR CELLS · REFECTORY · MINOR CELLS

MONKS' QUARTERS · MONKS' QUARTERS

LECTURE HALL

BELFRY · SUTRA REPOSITORY

CORRIDOR

MIDDLE GOLDEN HALL

WEST GOLDEN HALL · EAST GOLDEN HALL

PAGODA

INNER GATE

SOUTH MAIN GATE

Hoko-ji
(late 6th c.)

SUTRA REPOSITORY

BELFRY · LECTURE HALL

GOLDEN HALL

PAGODA

INNER GATE

SOUTH MAIN GATE

Shitenno-ji
(early 7th c.)

LECTURE HALL

SUTRA REPOSITORY · BELFRY

CORRIDOR

PAGODA · GOLDEN HALL

WEST MONKS' QUARTERS · EAST MONKS' QUARTERS

INNER GATE

SOUTH MAIN GATE

Horyu-ji
(late 7th c.)

23. *Restored compounds of Hoko-ji, Shitenno-ji, and Horyu-ji.*

further evidence of their zeal. The Hoko-ji pagoda must have been built on a grand scale, as well, for it was supported by a massive centerpost, and relics have been found buried at a considerable depth. This building is thought to have been the first in Japan to have tile roofing.

The worship of religious relics and statues of the Buddha was an important part of Buddhist practice in sixth-century Japan. People believed in the boundless power of Sakyamuni, the historical Buddha, and prayed devoutly for freedom from afflictions, for good harvests, and for the defense of the nation. Minute particles of sacred bone relics were believed to contain the power of Sakyamuni, and the pagodas housing them were built high to symbolize this power. Statues of buddhas and of bodhisattvas, the perfected beings who reject nirvana in order to remain in the world to assist in the salvation of mankind, were also objects of adoration

as living images harboring the presence of the deity.

During the earliest stages of the development of Buddhist iconography in India, the depiction of the Buddha in human form had been eschewed out of a sense of reverence for a holiness that could not be represented in recognizable shape. Gradually, however, an anthropomorphic image of the Buddha emerged at Gandhara in northwestern India (present Pakistan and Afghanistan), where the religion came into contact with the traditions of Greek art and its idealized human form. Thereafter, only at times when relics alone were believed to be efficacious did statues of the Buddha temporarily cease to be made.

A great change took place in the Buddhist art of Gandhara when Buddhist images modeled on classical Greek statues began to be made in the first century A.D. Like the statues of the gods of various ancient cultures, statues of the Buddha were

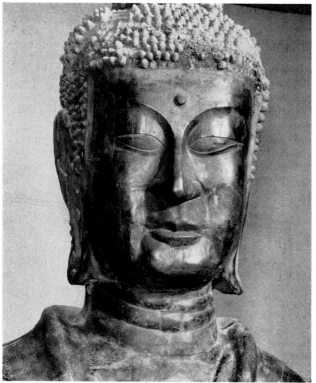

24. *Great Buddha of Asuka, by Tori. Bronze; height, 275.7 cm. 606. Ango-in (on the site of Hoko-ji), Nara.*

thought to possess mystical, supernatural properties. To adoring believers, they became living beings. In classical Greece, statues of gods were more than awe-inspiring images imbued with mysterious powers; as the ideal of man himself, they bore facial expressions suggesting that the will of the gods could be surmised by human intelligence or intuition. Following Greek models, the sculptors of Gandhara did not stop at showing the transcendental, mystical qualities of the buddhas and bodhisattvas. They also tried to depict such virtues as wisdom and compassion in ways that could be immediately recognized and comprehended by worshipers.

However, East Asian peoples, unaccustomed to seeing their deities in human guise, lacked the sophistication that would allow immediate comprehension of Gandharan Buddhist art. Before this art could be assimilated with local traditions in

China and Japan, the mystic power of Buddhist statues and the worship of relics had to be fully understood. These stages of absorption can be seen in the Buddhist sculpture of the Six Dynasties period in China and the Asuka period in Japan. Through the successive stages of study of classical Gandharan models and gradual assimilation of their artistic forms and techniques, human qualities came increasingly to be stressed in religious art and a greater naturalness appeared in the expression of both spiritual and physical qualities. These stages in Japan were realized in the sculpture of the Nara and Early Heian (794–897) periods.

The worship of Buddhist statues as living, divine beings was not restricted to the early exoteric sects; in fact, the tendency became stronger in the Esoteric sects of the Heian period (794–1185). The religious devotions practiced by the great priest Genshin before a statue of Amida (Amitabha)

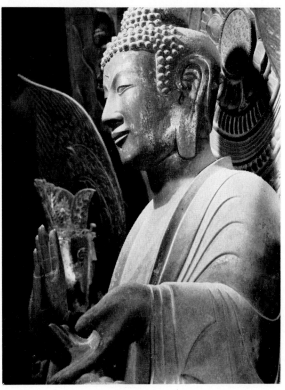

25. Shaka Buddha of the Shaka Triad, by Tori. Bronze; height, 86.3 cm. 623. Kondo, Horyu-ji, Nara.

Nyorai indicate that Buddhist statues were considered to have a reality over and above that of a mere symbol.

Early in the seventh century, Empress Suiko commissioned Tori Busshi to cast in bronze a great statue for the Hoko-ji. Since there had been no earlier tradition of anthropomorphic representation of the native Shinto deities or large-scale sculpture of any kind, this must have been a tremendous undertaking for Japanese society at the time. Ceremonies of invocation for the descent of divinities had been performed with the three ritual objects, mirrors, *magatama*, and swords, attached to sacred *sakaki* trees erected for the purpose, but it is unlikely that sculptures of gods in human form had ever been attempted in Japan. Tori's grandfather, a bronze-harness maker, had worshiped a statue of Sakyamuni and his father, Tasuna, had made wooden and embroidered repre-

sentations of the Buddha, so Tori was certainly not ignorant of the Buddha image. The immediate prototypes of the Great Buddha of the Hoko-ji (Fig. 24), also known as the Great Buddha of Asuka after the site of the temple, were the seated buddhas of the Chinese Northern Wei (386–534) style transmitted to Paekche and other parts of Korea. As the late archaeologist Seiichi Mizuno has pointed out, the seated Sakyamuni (completed between 504 and 523) that is the principal image in the Pinyang Cave at Lungmen in North China is an excellent example of this style. In his gilt-bronze sculptures, notably the Sakyamuni of the Horyu-ji triad, Tori achieved an expression of dignity superior even to that of the Northern Wei sculptures.

Using the Northern Wei style transmitted via bronze, wood, and embroidery, Tori was able to realize in bronze the form of the "Great Deity from China" that had gradually taken shape in his mind.

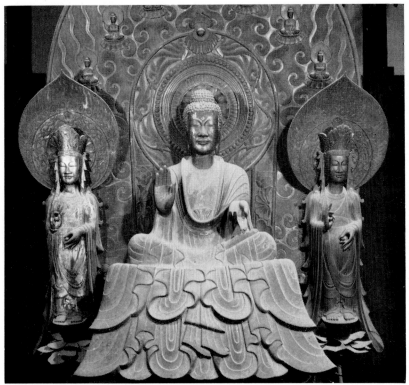

26. Shaka Triad, by Tori. Bronze; height of Shaka Buddha, 86.3 cm. 623. Kondo, Horyu-ji, Nara.

Keen spiritual tension combined with a strong virile quality is characteristic of his statues and of most Japanese sculpture of this period. The delineation of eyes, nose, and mouth is particularly impressive. It is as if Tori had been attempting to idealize the image of the emperor, the sovereign power of the Japanese world.

Because the mandorla of the Hoko-ji Sakyamuni has suffered heavy damage and many unfortunate repairs, it is difficult to judge the overall appearance of the original work. But we can say that it expresses more materiality in the treatment of body and draperies than does the later Shaka Triad in the Horyu-ji (Fig. 26).

As the Hoko-ji declined, Tori's great gilt-bronze statue was damaged when the building housing it was destroyed. Today it is enshrined in the small Ango-in temple at Asuka, near Nara. It still sits on its original stone pedestal, but the pathetic repaired

image seems lost in melancholy recollection of its former glory. Because of extensive repairs little can be said of Tori's treatment of the torso and drapery. But despite the vicissitudes it has undergone, the power of the Great Buddha of Asuka continues to be felt today.

Tori's greatest masterpiece is the Shaka Triad (Sakyamuni with two bodhisattva attendants; Fig. 26) in the *kondo* of the Horyu-ji. According to an inscription on the back of the mandorla of the group, it was in 622, when Prince Shotoku and Princess Kashiwabe had fallen ill, that Tori vowed to make a statue of Sakyamuni as tall as Shotoku, as a votive offering dedicated to their recovery. The statues and the altar fittings were completed the following year. In this group Tori uses the Northern Wei style with total confidence, his sure hand resulting in what may be called the "Tori style."

Strong in expression and unified by a spiritual

27. *Mandorla of west attendant of the Shaka Triad, by Tori. Height, 58.8 cm. Kondo, Horyu-ji, Nara.*

28. *Mandorla of Shaka Buddha of the Shaka Triad, by Tori. Bronze; height, 175.6 cm. Kondo, Horyu-ji, Nara.*

tension, the triad comprises an impressive composition. The chiseled finish of the figures is sharp (Fig. 25), and the details of the large and small mandorlas (Figs. 27, 28) have been executed with great care. At the same time there is an attractive, unpolished quality to the group. The mandorlas of the bodhisattvas are embellished with an abstract pattern of curved lines of the "coiled dragon" type, while the large one that serves as a background for the entire group contrasts old and new elements, with relatively naturalistic lotus designs surrounded by flames. Seven small buddha figures are worked into the overall design of the large mandorla.

The whole is conceived in terms of extensive flat surfaces, unity of composition being achieved by the triangular form of the Sakyamuni in the center, his face coinciding with the central ring of the large mandorla and forming the focal point of the group. The gracefully curving lines representing folds in

the Buddha's robes draped over the dais direct the gaze of the faithful up along the torso to his face. The strong curves of the flame motif, rising repeatedly over the large mandorla, echo the rhythms of sutra and prayer chanting. At the center of this magnificent cosmic composition, in the guise of Sakyamuni, sits Prince Shotoku himself.

As the art historian Seiroku Noma has pointed out, Tori's connection with the art of bronze-saddle making should not be ignored. The unusual curvilinear patterns seen in the openwork of bronze saddles excavated from tumuli (see Foldout 1) survived into Asuka art in Tori's work. As seen in these later developments, the patterns represent the final flowering of the tradition of abstract ornamental composition in early Japanese art.

The nonrepresentational patterns of Asuka art retain the *c* motif as their basic unit, but utilize it in very different ways from the Jomon patterns. Ex-

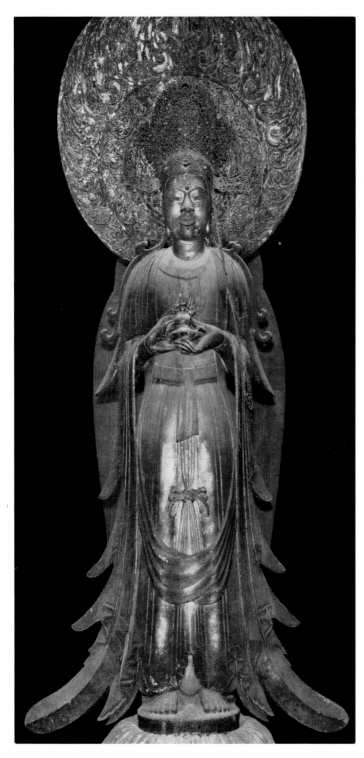

29, 30. *Guze Kannon and mandorla. Wood and gilt lacquer; height of figure, 197 cm.; height of mandorla, 112 cm. First half of seventh century. Yumedono, Horyu-ji, Nara. (See also Figure 35.)*

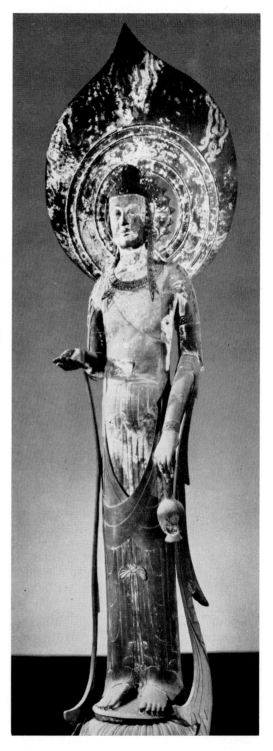

31, 32. Kudara Kannon and mandorla. Painted wood; height of figure, 209.4 cm.; height of mandorla, 113.3 cm. Second half of seventh century. Treasure Museum, Horyu-ji, Nara.

pansions of the *c* motif into palmettes and *x* motifs are large, complex, and consequently richer. There are extensive networks of the *c* motif or small *c*'s branching off from large *c*'s like a proliferating vine. Joined in lines with a dragon's head and claws added, the "coiled dragon" motif is formed. With the addition of leaves, the motif becomes a honeysuckle scroll. When grouped into heart shapes, it forms a palmette or small palmettes within a larger one (see Foldout 1). Separated, the motifs may form flame and cloud patterns. Absorbing all animal and plant motifs into its network of curves, the system constitutes a kind of schema of universal life. It is truly a powerful and elegant system.

These curved patterns are different from the *lei-wen* (meander) group of motifs of China, and probably derive from northeast Asia rather than China. The greatest development of the curve motif since the bronzes of the early Ch'in period (221–206 B.C.) and the applied arts of the Han dynasty (206 B.C.–A.D. 220) is to be seen in the decorations of

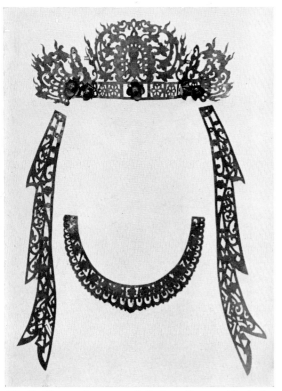

34. *Coronet of Guze Kannon (facsimile; original from first half of seventh century).*

33. *Necklace and coronet of Kudara Kannon (facsimile; originals from second half of seventh century).*

35. *Guze Kannon. Wood and gilt lacquer; height, 197 cm. First ▷ half of seventh century. Yumedono, Horyu-ji, Nara Prefecture. (See also Figure 29.)*

Northern Wei Buddhist caves. The superb Northern Wei elements are themselves probably the source of the radically new composition of the cave murals at Tun-huang in Kansu Province, China.

We recognize in Tori's Shaka Triad in the Horyu-ji the influence of the curved motif that swept across East Asia like a whirlwind from the third century B.C. to the sixth century A.D. In this work, Tori synthesized anthropomorphism, the new system of abstract curve patterns, and geometrical composition. The geometrical component is so strong that the curve motif is often overlooked.

Another masterpiece of Asuka Buddhist sculpture is the wooden statue of Kannon, generally known as the Guze Kannon (World-saving Avalokitesvara; Figs. 29, 35), in the octagonal Yumedono (Dream Hall) at the Horyu-ji. The coronet (Fig. 34) and

mandorla (Fig. 30) and the curving lines of its hair and robes echo the system of curved motifs discussed above. The soul of the image seems in sympathy with the spirit permeating the universe; surely there is no other Japanese statue that produces so spiritual an effect. Perhaps only some sacred wooden image worshiped by the ancient Greeks could have created a comparably profound impression.

The Kudara (Paekche) Kannon (Fig. 32), also in the Horyu-ji, is a masterpiece of the new age. Its slender, elongated figure is comprised of lines of beauty and spirituality. The serene expression of the face warmly welcomes the pious, and the height of the statue promises boundless compassion and love that can be trusted utterly. The metal openwork ornaments of the Kannon (Fig. 33), like those of the statues of the Four Celestial Guardians in the

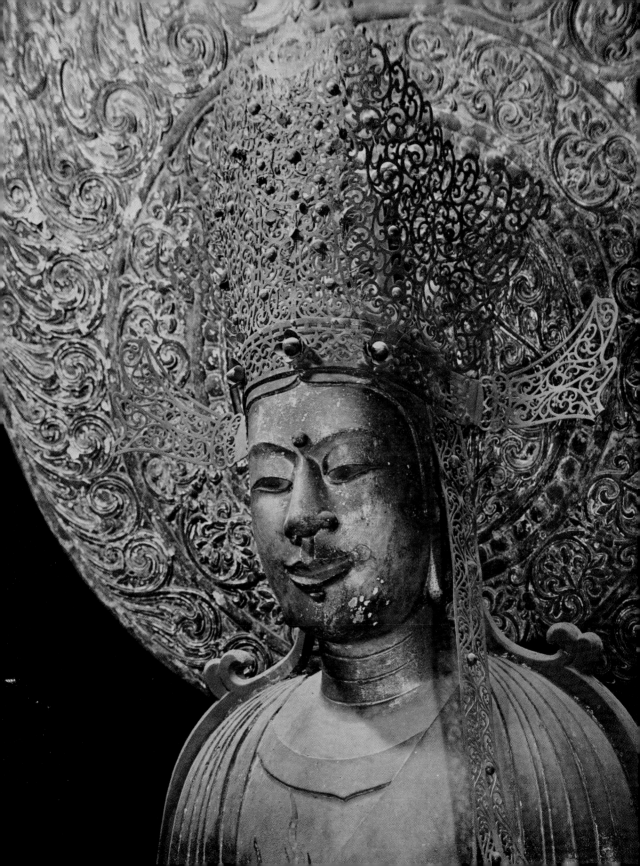

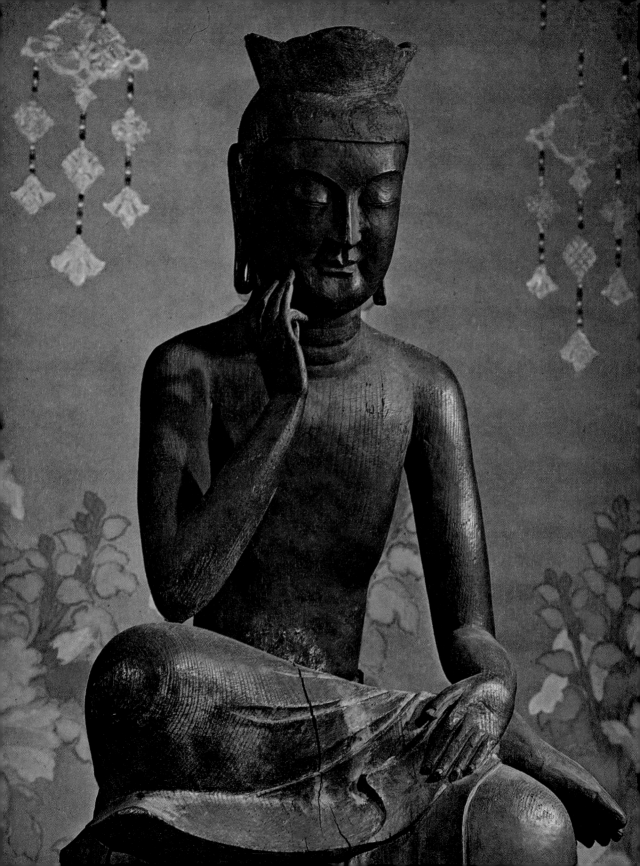

37. *Lady Maya and attendants (three of forty-eight Buddhist statues). The Buddha is seen emerging from his mother's sleeve. Gilt bronze; height of Lady Maya, 16.7 cm. Seventh century. Tokyo National Museum.*

◁ 36. *Miroku Bodhisattva. Wood; height, 123.5 cm. First half of seventh century. Koryu-ji, Kyoto.*

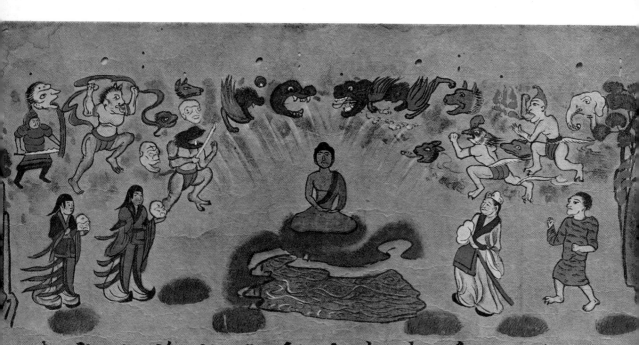

等諸惡纇形不可稱
數圍繞菩薩或復有
欲裂菩薩身或四方
烟起炎爛衝天或狂
風奮蔽震動山谷風
火烟塵暗无所見四
大海水一時涌沸諸
法天人諸龍鬼等悉
怒魔衆瞋恚增盛毛
孔面流淨居天衆見
此惡魔憫離菩薩以
慈悲心而愍傷之於
是來下側塞虛空見
魔軍衆无量无邊圍
繞菩薩蕪大惡聲震

38. E Inga-kyo *(Illustrated Sutra of Cause and Effect)*. *Colors on paper; height, 26.3 cm. Eighth century. Ho-on-in, Daigo-ji, Kyoto.*

39. *Kannon Bodhisattva (detail of mural of Amida's Paradise). Dimensions of mural, 313×260 cm. C. 700. Kondo, Horyu-ji,* ▷ *Nara Prefecture. (Destroyed by fire, 1949.)*

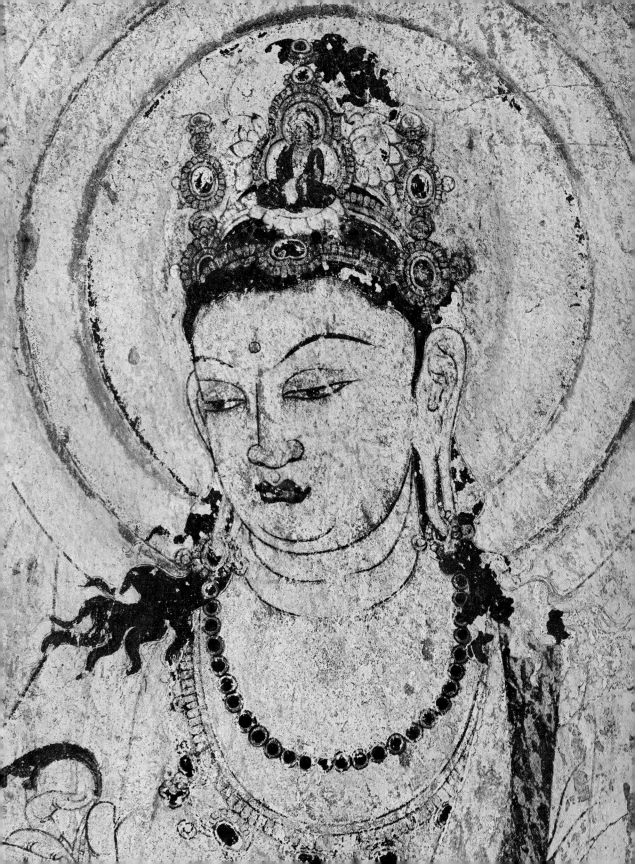

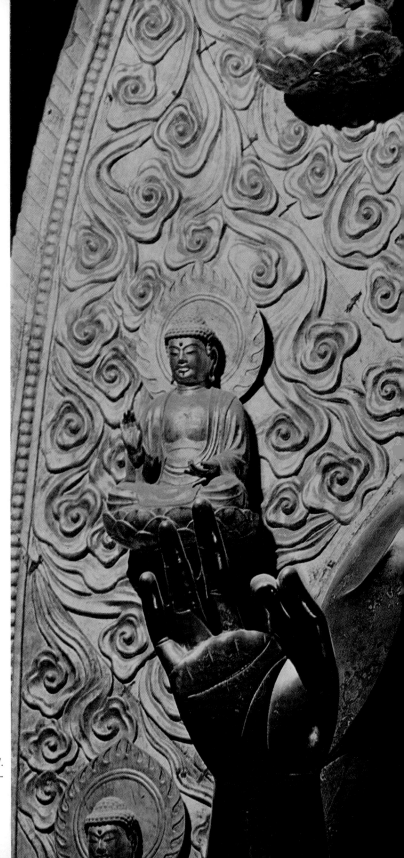

40. *Yakushi Nyorai of the Yakushi Triad. Bronze; height, 254.7 cm. Late seventh century. Kondo, Yakushi-ji, Nara.*

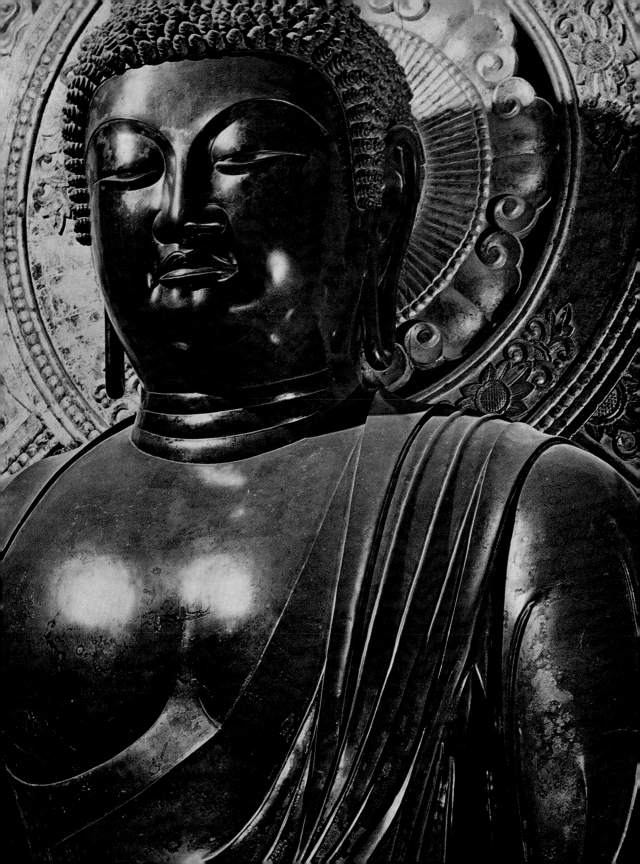

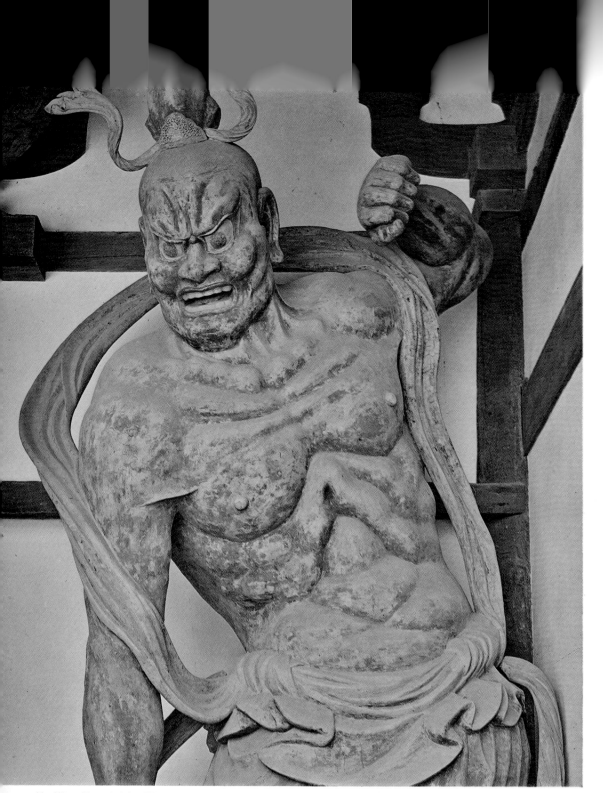

41. *Ni-o. Clay; height, 378.8 cm. 711. Chumon, Horyu-ji, Nara Prefecture. (See also Figure 66.)*

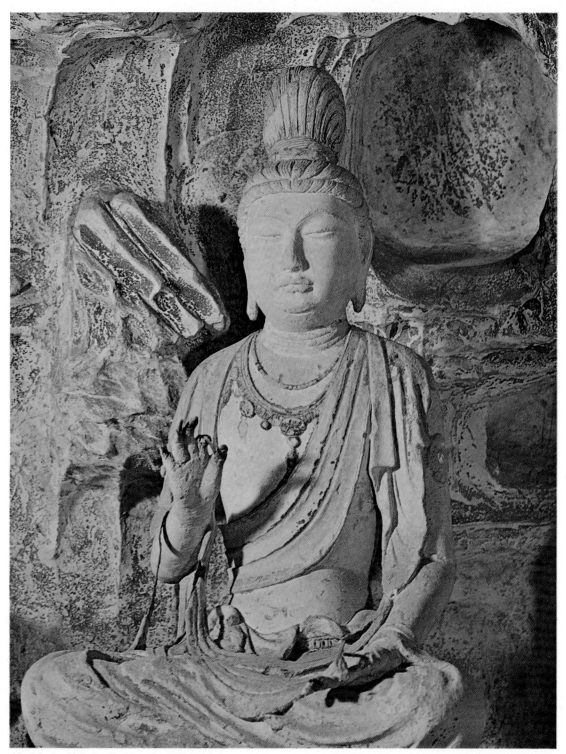

42. *Monju (Manjusri) from the Colloquy between Monju and Yuima. Clay; height, 50.9 cm. 711. Five-story Pagoda, Horyu-ji, Nara Prefecture.*

43. Subodai (Subhuti), one of the Ten
Great Disciples. Painted dry lacquer;
height, 145 cm. C. 734. Kofuku-ji,
Nara.

44. One of the Eight Supernatural ▷
Guardians. Painted dry lacquer; height,
173 cm. C. 734. Kofuku-ji, Nara.

45. *Bodhisattvas, engraving on mandorla. Bronze; height of mandorla, 231.8 cm. Eighth century. Nigatsudo, Todai-ji, Nara.*

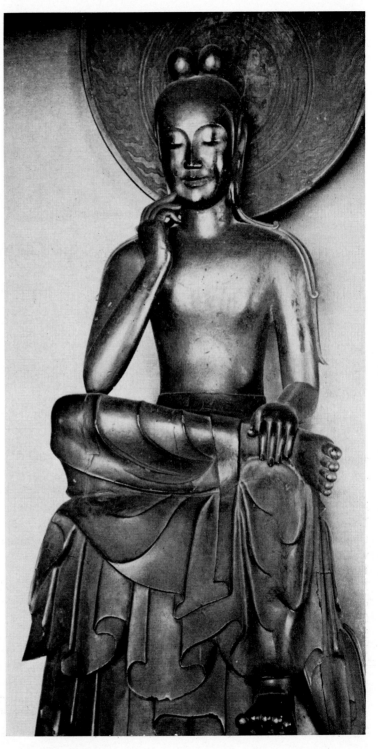

46. *Miroku Bodhisattva. Wood; height, 133 cm. Second half of seventh century. Chugu-ji, Nara.*

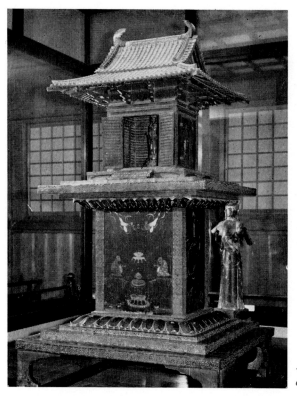

47. *Tamamushi Shrine. Painted wood; overall height, 232.7 cm. C. 650. Treasure Museum, Horyu-ji, Nara.*

same temple, have lost their mystical character and are used simply for decorative effect.

In the Chugu-ji nunnery, adjoining the Horyu-ji, is a beautiful small image of Miroku (Maitreya) Bodhisattva (Fig. 46), the Buddha of the Future, that is as affecting today as it must have been to the women of the seventh century. Amid the turmoil that followed Prince Shotoku's establishment of the Law of the Buddha in Japan, this statue of Miroku offered, with total humility and simplicity, a profound compassion for mankind. People praying to it are quickly enveloped in its contemplative ambiance. To draw the faithful directly into the heart of the bodhisattva, Miroku's meditating posture is represented with geometrical order and linear rhythm. The viewer's gaze is directed from the face to the right hand, right knee, left hand, dais, and finally back to the face again. The body and drapery are conceived as flat surfaces evoking a sense of unity and totality. All suggestion of the accidental or the actual is excluded, leaving the rhythm undisturbed and emphasizing the transcendental quality that pervades the image. Static though it is, it possesses a momentum and an expressiveness that penetrate directly to the heart.

THE TAMAMUSHI SHRINE Another treasure of the Horyu-ji that offers a direct view of Asuka's architectural and pictorial techniques is the Tamamushi Shrine (Fig. 47). The clean proportions of this altar bespeak the mastery of the artist who designed it. Set on a two-stage base, it is an idealized reproduction of contemporary architectural modes. A standing figure of Sakyamuni was once installed within the shrine, and the inner surfaces of the walls and

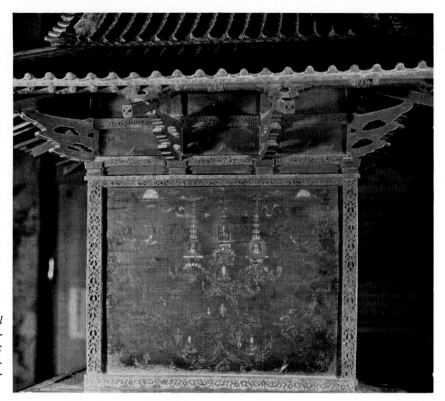

48. Tamamushi Shrine. Detail of back panel showing the Vulture Peak scene. Painted wood; overall height, 232.7 cm. C. 650. Treasure Museum, Horyu-ji, Nara.

doors are covered with the so-called Thousand Buddhas, innumerable tiny buddha images in relief. The paintings on the exterior walls are as lovely as they are important iconographically. Bodhisattvas and guardian deities are depicted on the doors, while the rear wall shows the scene of the Buddha's sermon—the preaching of the *Lotus Sutra*—on Vulture Peak (Grdhrakuta; Ryo-zen or Ryoju-sen in Japanese; Fig. 48). Paintings on the front of the base show monks and heavenly beings, and on the rear is a representation of Mount Sumeru, the central peak of the world according to Buddhist cosmology. The sides of the base (Figs. 49, 50) illustrate *jataka* tales, stories based on former lives of the Buddha, showing his sense of sacrifice and his spirituality.

This shrine is, in fact, an embodiment of the theological principles of the Buddhism of that time, based primarily on the *Lotus Sutra,* and the arrangement of the images in it constitutes a magnificent mandala. Sakyamuni stands in the center with the Thousand Buddhas on all sides. Surrounding this central group is the first ring formed by the bodhisattvas and the Four Celestial Guardians; a second ring consists of the Vulture Peak scene, incense-offering scenes, and illustrations of moral parables of self-sacrifice and devotion. Finally, the outermost ring depicts Mount Sumeru and the ocean. Had this depiction of Sakyamuni had a small seated figure of Miroku on its head and heavenly figures scattering flowers around it, the mandala would have been complete.

The Tamamushi Shrine represents Sakyamuni, surrounded by the Thousand Buddhas, as a suprahistorical being presiding over the universe. The conception is like that of the later great buddhas,

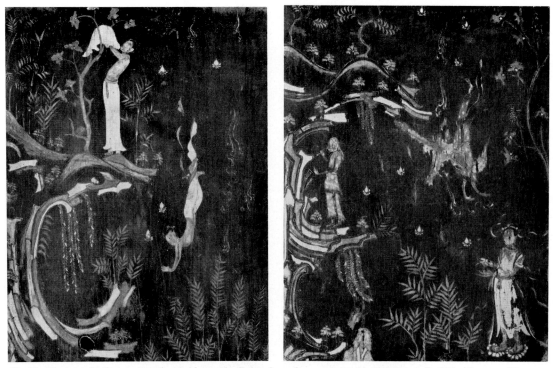

49, 50. *Tamamushi Shrine. Details of side panels. Painted wood; overall height, 232.7 cm. C. 650. Treasure Museum, Horyu-ji, Nara.*

such as the one at the Todai-ji, Nara (c. 752). The astounding flash of intellect or intuition that made such a conception possible can be seen in every part of the shrine. The honeysuckle and palmette curves of the metalwork (see Foldout 1), originally enhanced by the greenish gold glint of beetle wings, envelop the structure in the mystery of ornament. The curved motifs have even penetrated the paintings on the walls. Banks, clouds, trees, and human figures describe multiple curves. Men and natural forms are woven into a great rhythm, as if in an epic poem, and are made to tell the tale of the fate of a world. Just as the anonymous author of an epic is not free to choose or change his rhythms, so these artists could not alter the rhythm of their patterns at will. How were they to free themselves from the mystical power of the design motifs? Adopt geometricalism? Naturalism? Once, Yayoi people had

used geometry to liberate themselves from the spells of Jomon designs; in this case both geometry and naturalism were used. The art of the Hakuho period integrated the two and arrived ultimately at an austere classicism.

The Tamamushi Shrine remains the only fully reliable model of Asuka architecture. The cloud-shaped column brackets, known as *kumo-hijiki*, or cloud brackets, are further manifestations of the curve motif. Those of the Horyu-ji *kondo* (Fig. 51), with their repeated small cloud shapes, show the obsession with ornamentation particularly well. A similar dominance of the applied arts is to be seen in early medieval European art, from the rise of the German states to the period of the Carolingian Renaissance. There, decorative motifs, especially those originating in metalwork crafts, are found even in the ornamentation of stone buildings. The

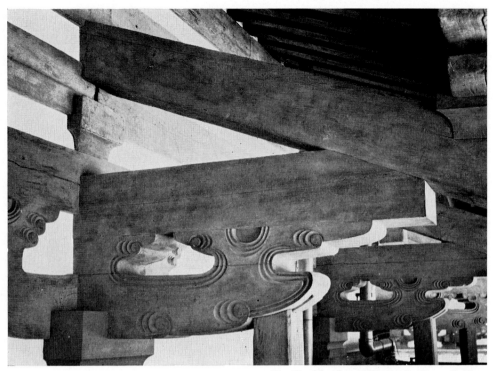

51. *Cloud brackets. 679. Kondo, Horyu-ji, Nara.*

Japanese use of *kumo-hijiki* parallels this phenomenon. Especially in the case of the Horyu-ji *kondo*, the *kumo-hijiki* have become so sophisticated that the original bracket form is hardly discernible.

DEVELOPMENT OF THE KONDO In 670, the Horyu-ji was entirely destroyed by fire. The project of rebuilding the temple apparently began immediately, for it is believed that a new *kondo* was completed by 680 and that the pagoda and central gate were finished by 693. The clay statues were installed by 711. The rebuilding of the Horyu-ji occurred at a time of great architectural activity: the periodical rebuilding of the shrines at Ise had been established as a regular event in 690 in the case of the Inner Shrine and 692 in the case of the Outer Shrine, and the architectural style of the shrine was permanently fixed. The decision to build the Yakushi-ji, representing various styles of monumental architecture, was made in 680.

The interior of the rebuilt Horyu-ji *kondo* (Figs. 52, 54) is divided into three sections. In the center of the building is the Shaka Triad, Tori's memorial to Prince Shotoku. On the west is installed the statue of Yakushi Nyorai (Bhaisajyaguru; Fig. 53), commissioned by Emperor Yomei. (The original statue was lost, and the present one appears to date from the time of the rebuilding of the temple.) On the other side of the triad is a statue of Amida. (The image cast at the time of the rebuilding was lost, and the present work is a Kamakura-period copy made by Kosho, the son of the master sculptor Unkei.) Three great canopies are suspended above the sculptures, and the combination of canopies and statues and their bases constitutes three small

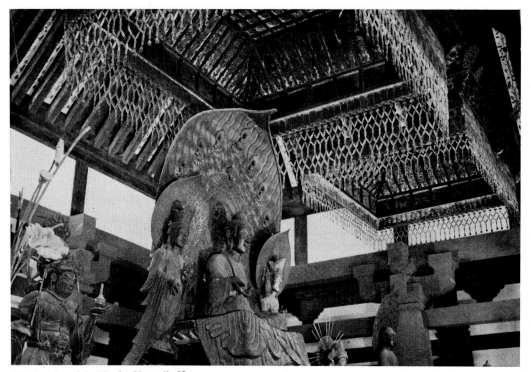

52. *Interior of the Kondo. Horyu-ji, Nara.*

universes, of Shaka, Yakushi, and Amida, within the *kondo*. In the Horyu-ji *kondo* is realized the wish to honor Prince Shotoku and to display the glory of the Buddhist faith that had flourished so magnificently in the half-century since the prince's death. Murals of the paradises of four Buddhas (Shaka, Amida, Yakushi, and Miroku) and their accompanying bodhisattvas (Figs. 39, 77) served to extend this noble and ambitious scheme. (They were lost in a fire in 1949.)

The ceiling of the *kondo* symbolizes the heavens, and the interior as a whole represents the world of the buddhas, while the statues placed within this space and the paintings on the walls present this world in concrete form.

The architecture of a universal religion is ideal evidence for the proud claim that it is the function of the art of architecture to create an image of the universe. Christian churches and Muslim mosques

both represent God's kingdom on earth, and their interiors realize a lofty, heavenly space. Similarly, the pagoda and *kondo* of a Buddhist temple symbolize the universe of the buddhas. The architectural form chosen, in both the West and the East, to represent the universe most effectively is the domed building.

Whether derived from the round tumulus form or from the tumulus with a domelike rock chamber, the origins of the dome extend back to the remote past. As a memorial structure, the domed building dates back to the round shrines of the ancient Greeks and the octagonal sanctuaries that are their Greco-Oriental variants. A third important type of dome arose in Parthian and Sassanian Persia (first to seventh century A.D.). This was a dome constructed over four walls built on a square ground plan, and was the basic model for Byzantine churches and Muslim mosques.

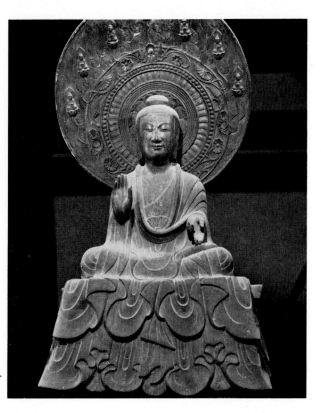

53. Yakushi Nyorai. Bronze; height, 63 cm. Second half of seventh century. Kondo, Horyu-ji, Nara.

We surmise from the remains of temples and temple caves in Central Asia that octagonal and square domed structures were eagerly incorporated into early Buddhist architecture; and their influence is reflected even in the wooden *kondo* of Japanese temples.

From the outside, the Horyu-ji *kondo* appears to be a two-story building, but actually the interior has only one story, as the second serves no function. By contrast, the later *kara-yo* style of Buddha halls of certain Zen temples is two-storied both outside and inside. Four main pillars support a high, paneled ceiling, and the space created by thrusting up to the second-story ceiling, combined with brackets and other structural timbers, forms a brilliant representation of the universe. Be that as it may, the two-story form of the Horyu-ji *kondo* had a dome prototype.

The *kumo-hijiki* brackets used in the *kondo*, pago-da, and main gate of the Horyu-ji give these buildings an intricate, rather archaic appearance. The basic bracket structure, however, is simple and straightforward. The clean proportions of the various parts of the *kondo* and pagoda and the positioning of these buildings within the surrounding cloisters were mathematically determined. This sort of arithmetical lucidity has something in common with the open facial expressions and concise forms of the sculpture of the Hakuho period.

The viewer is impressed by the integral order of the pagoda and *kondo*, standing neatly side by side within the cloisters of the Horyu-ji, and by the beauty of space rhythmically measured out by the pillars of the cloisters. The cylindrical form of the pillars plays a crucial role in this architecture. Their importance as a structural unit goes without saying, but they also serve as important expressive elements.

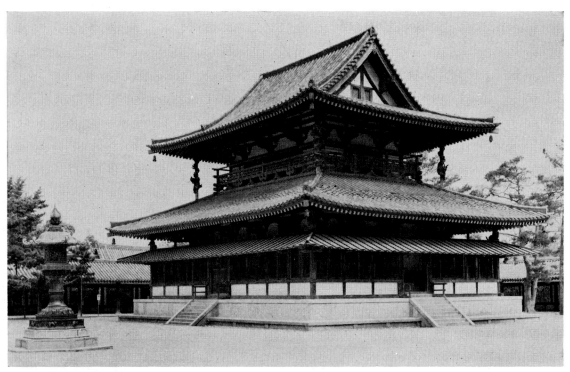

54. Kondo. 679. Horyu-ji, Nara.

CLASSICAL ARCHITECTURAL STYLE

In the Tumulus period, Japan's native architecture, using iron tools, established the prototypes of later shrine architecture and of the palaces of the capital, Heijo (later to be renamed Nara), with their gabled roofs and embedded pillars. We may easily imagine that thus was nurtured a national architectural style and sensibility. Probably this is when a preference for thick pillars embedded in the ground developed.

Then Buddhist architecture was introduced. Since Han times, Chinese architecture had been the international style of the East Asian world, and early Japanese Buddhist architecture was indeed Chinese architecture. In particular, it modeled itself on the classical harmony of the T'ang style. Hence Japanese architectural thought of the period, and in turn attitudes toward the shaping of man's public and private living space in general,

were liberated from the closed, insular Japanese environment. Henceforth Japanese architecture was to be tempered with an international attitude, although new modes would naturally be adapted to the Japanese land and climate, leading eventually to a characteristically Japanese classical style.

Thick pillars set in a row and connected by beams, a roof framework on top of this, and finally a roof of the hipped and gabled type are elements typifying the new architecture of trabeated wooden buildings. The most characteristic features, both functionally and aesthetically, are the pillars and brackets, the latter in particular being so important as to virtually determine the style as a whole. Using the architectural details of the Tamamushi Shrine and the excavations of ruins, as well as analogies with details of Northern Wei cave architecture in China, it is possible to reconstruct the style of Buddhist architecture at the beginning of the Asuka

55. *The compound of Horyu-ji seen from the ambulatory. Nara.*

period. As can be seen from the recently rebuilt Shitenno-ji temple in Osaka, all the timbers utilized were probably thick, giving an impression of crudeness. The Yakushi-ji (Fig. 56), having abandoned cloud-ornamented brackets for plain ones, already exhibits a classical harmony. In the Hokkedo, or Lotus Hall, of the Todai-ji, built in the mid-eighth century, the brackets have a strong, dignified simplicity, and in the late-eighth-century Toshodai-ji, also in Nara, they have achieved a balanced, mature form.

In the arrangement of the buildings of a Buddhist temple, the *kondo* has a central position and the pagoda is an accessory to it. With certain exceptions, such as the unusually large *kondo* of the Todai-ji, the form of the *kondo* was standardized in the Nara period: seven *ken* (bays) long and four *ken* deep with a single-story hipped roof, as seen for example in the Toshodai-ji *kondo* (Fig. 57). This

became the pattern for *kondo* in the *wa-yo*, or Japanese style, and was strictly followed during the subsequent Heian, Kamakura (1185–1336), and Muromachi (1336–1568) periods. As has been pointed out by the art historian Minoru Ooka, this can be seen as one example of classicism in Japanese architecture. The original Yakushi-ji *kondo* was a grandiose two-story building with a secondary roof, called a *mokoshi*, at each story—a large, complex structure, the *mokoshi* giving it an elaborate appearance. A classical style, as seen for example in the interior of the Pantheon in Rome, is characterized by a grandiose, unified form that is the culmination of various stages of experimentation. The four- by seven-*ken* formula for the *kondo* was arrived at in the same way. This striving for an ideal form for the *kondo* can be seen in the disposition of the pillars, which, while satisfying structural requirements, leaves a large central space and at the same

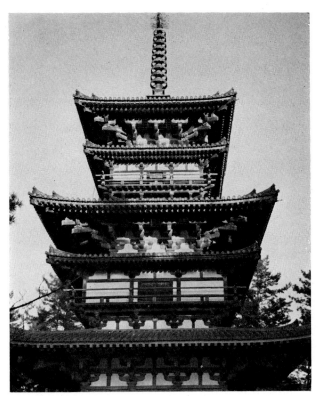

56. *Three-story East Pagoda. 730. Yakushi-ji, Nara.*

time gives a stable, more or less square shape to the wall sections marked off by the pillars and beams.

The façade of the *kondo* is formed by a portico one bay deep. This feature is present in all the *kondo* architecture of the exoteric Buddhist sects, although in later periods the portico was hidden by the insertion of door panels between the pillars. The same basic design is followed in such a large buddha hall as the Sanjusangendo in Kyoto. This kind of portico must have been an important element of Japanese classical architecture, so that even when hidden later, the original intention was nevertheless honored.

Thus the structural logic of the temple architecture of the Hakuho and Tempyo periods becomes clear, and the problem of the union of pillars, bracketing, beams, and roofing finds a solution in a harmonious form that is simple without being crude, neither too elegant nor too complex. Clarity and harmony are born of the relationship between human beings and architecture, and while neither as simple nor as clear as in the Greek and Roman classical styles, human proportions were applied in Hakuho and Tempyo temple architecture.

The scale is truly a human one. The pillars reflect the proportions of the human figure and function as humanizing elements. We look at and appreciate buildings with the human figure as our standard, and harmony and organization are here clearly perceivable. This sensitivity to the human scale continues throughout the history of Japanese architecture, from the temples of ancient times to residential and *chashitsu* (rooms designed for the tea ceremony) architecture of the Edo period (1603–1868). However, there is one important qualification that must not be overlooked:

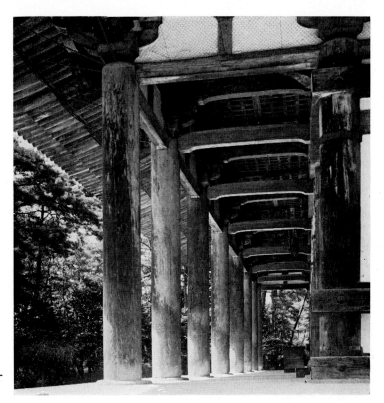

57. Portico of the Kondo. 770–80. Toshodai-ji, Nara.

while the humanism of the Edo period was an idealization of real men, of the people in general, that of ancient times was a humanism of an elite, of godlike heroes. Although both make use of the proportions of the human figure, the scale of the latter is not that of the common people. It is the scale of heroes and giants—of the gods. This is the character of the classical style in Japan.

In the classical styles of Greece and Rome, the column was quite clearly designed according to the proportions of the human figure. So closely were the two related that plain columns were sometimes replaced by ones in the form of a female figure. A structure was decorated by setting a row of columns into a wall, shaped into human form and made into a work of architecture. Furthermore, the colonnade gave order and rhythm to outdoor space, converting it into human space. It is impossible to conceive of the space in which the ancient Greeks and Romans lived without their colonnades. The entrance to a temple or residence had a portico; open spaces were surrounded by colonnades forming arcades. Colonnades and arcades of this classical type were adopted in the Greek-style Buddhist buildings of Gandhara. The *stupa* (equivalent to the pagoda in East Asia) housing relics of the Buddha was positioned in the center of a colonnaded ambulatory like that of an atrium. And the front entrances of sacred edifices were probably provided with porticoes like that of the Pantheon in Rome.

Thus, via Gandharan Buddhist architecture, the Horyu-ji veranda corridors (Fig. 55) are related to the colonnaded ambulatory of distant Greece and Rome, and both the octagonal Yumedono of the Horyu-ji and the Toshodai-ji *kondo* (Fig. 57), with its one-bay-deep portico, are distant relatives of the

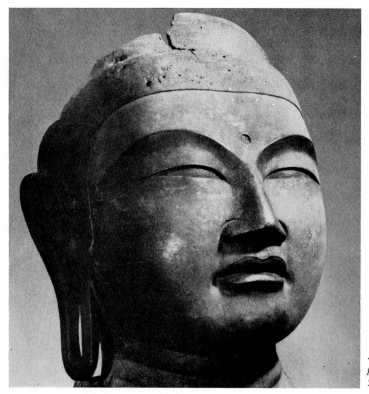

58. Head of Yakushi Nyorai (originally principal image of Yamada-dera). Bronze; height, 97.3 cm. 685. Kofuku-ji, Nara.

Pantheon. But the formal concepts that reached Japan were not merely copies or variations of classical architecture. In Nara they were revitalized and, realized in new materials and forms, provided the basis for a native Japanese classicism.

HAKUHO SCULPTURE: THE AWAKENING OF SELF-AWARENESS In the latter half of the seventh century, the sculpture of the period known in art history as Hakuho (literally, "White Phoenix") consisted of styles carried over from the reign of Empress Suiko, such as the Northern Wei and Southern Liang (502–57) of China. Alongside these earlier prototypes were the newly introduced Northern Ch'i (550–77) and Northern Chou (557–81), Sui, and early T'ang styles.

In the Shaka Triad in the Horyu-ji *kondo,* the Kudara Kannon, and the Chugu-ji Miroku, we see that a youthful image of man is already present, and we seem almost able to sense its future development: first there are the Yumetagai Kannon (literally, "Dream-Changing Kannon," so called because of a belief that the image changes dreams of bad omen to good dreams) at the Horyu-ji, the Ko Yakushi belonging to the Shin Yakushi-ji, and the Shaka Buddha at the Jindai-ji in Tokyo (Fig. 59); then we have the principal image of the Yamada-dera (now in the Kofuku-ji; Fig. 58), dedicated in 685, the Miroku of the same year, which is the principal image at the Taima-dera (Fig. 61), and the Sho Kannon in the Toindo hall of the Yakushi-ji (Fig. 63); and finally there is the Yakushi Triad in the *kondo* of the same temple (Figs. 40, 62). An echo of this development is seen in the triad of Lady Tachibana's Shrine (Fig. 60). With

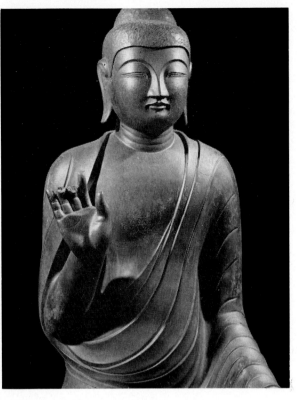

59. *Shaka Buddha. Bronze; height, 81.8 cm. Second half of seventh century. Jindai-ji, Chofu, Tokyo.*

each work, self-awareness becomes clearer and self-confidence grows. We are reminded of the development in Greek sculpture from the Late Archaic to the Early Classical period.

The rationalistic handling of the draperies of the Chugu-ji Miroku anticipates the flow of the drapery of the Jindai-ji Sakyamuni. The Jindai-ji sculpture develops the treatment of drapery further, adding a certain asymmetrical quality to it.

Unfortunately only the head of the Yamada-dera figure remains. Although at first sight it seems hardly more than a simple mask, it is a full, subtly modeled face, about halfway in the development from the Ko Yakushi at the Shin Yakushi-ji to the Ten Great Disciples of the Buddha at the Kofuku-ji (Fig. 43).

The principal image at the Taima-dera, Miroku Bodhisattva (Fig. 61), shows a new softness. It has

a deep, boldly modeled torso, and the drapery falls in soft, natural undulations over the edge of the base. In its serious, dignified expression one sees the spirituality of the Buddhist image attaining a classical majesty. In fact the Miroku of the Taima-dera reminds us of the statue of Yakushi, the Buddha of Healing, in the Yakushi-ji.

The Sho Kannon (Fig. 63) in the Toindo of the Yakushi-ji, together with the Yakushi triad in the *kondo,* is a masterpiece not only of Japanese but of world sculpture. It expresses a profound spiritual purity without in any way sacrificing its humanity. The deep-torsoed figure shows the sculptor's interest in transitions between resilient planes, yet the physical quality is repressed in favor of abstract form, heightening the spirituality of the work. Pendant ornaments of a type new in Japanese sculpture hang from the neck and waist. The dig-

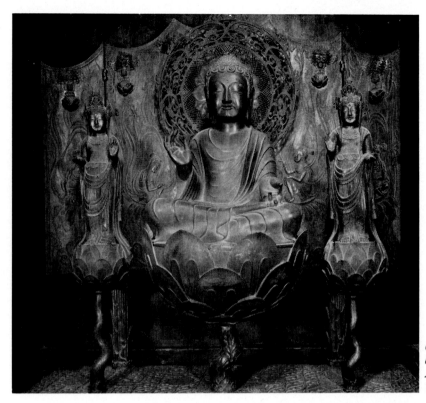

60. *Amida Triad of Lady Tachibana's Shrine. Bronze; height of Amida, 33.3 cm. Eighth century. Treasure Museum, Horyu-ji, Nara.*

nified features of the face have a gentle, Indian expression; the pupils of the large eyes are just visible behind the nearly closed lids. With its soft details, the whole of the upright figure is harmonized by bold, symmetrical modeling. The drapery too is geometrical, with left-right symmetry creating a rhythm reminiscent of the archaic style.

The Yakushi Triad (Figs. 40, 62) in the *kondo* of the Yakushi-ji is, as the art historian Takeshi Kobayashi has pointed out, the culmination of Hakuho sculpture. It has neither the discretion nor the hesitation of the Sho Kannon, but proclaims a grand conception of man, overflowing with an abundant strength. This triad, which dates from the late seventh century, is a fine realization of the majestic ideal of classical sculpture, though still a long way from that style's elegance. There is no question yet of the subtle expression of human

psychology. Instead the triad impresses with its power and authority, and in this respect is reminiscent of Tori's early Sakyamuni in the Ango-in. Both the Yakushi (Fig. 40) and the Nikko and Gakko (Fig. 62) bodhisattvas flanking him have the majesty of earthly rulers, and their dignified physiques remind us of Greek bronze sculpture of the classical period. Indeed, they show a solemn, spiritual quality not encountered even in Greek works.

This perfect expression of the physical can be seen clearly when the Nikko and Gakko figures are compared with the Sho Kannon. The weight of each of the attendant figures is supported on one leg, the other resting free; one hip is thrust forward. A sense of movement imparted to a figure in an attitude of stillness had been a tradition of Greek sculpture since the fifth century B.C., and the assim-

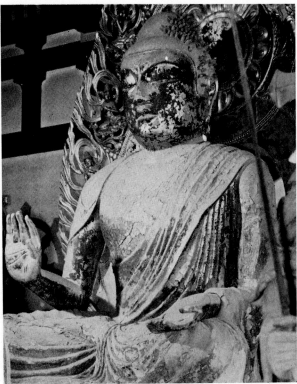

61. *Miroku Bodhisattva. Clay and gilt lacquer; height, 223 cm. 685. Kondo, Taima-dera, Nara.*

ilation of this principle, together with the tripartite division of the torso into chest and upper and lower abdomen (see Foldout 3), is clearly seen in the Nikko and Gakko figures, resulting in a beautiful and classical form.

Through the Greek-influenced Buddhist art of Gandhara, both India and China copied the classical Greek conception of the human figure, but in the one case, it was invested with a splendid sensual mysticism characteristic of the Indian tradition, and in the other, the emphasis fell on a typically Chinese physical, realistic quality. Compared with these, the Yakushi Triad, like the murals of the Horyu-ji *kondo,* is formalistic and comes closer to symbolism, exhibiting a strong concern for line, plane, and shape, and the rhythmic balance of these elements. In the eyes, nose, and lips of the three figures, and again in the finely executed hair

and pendants, nervous lines unify large planes and volumes. The drapery, particularly that of the principal image, has a smooth flow, and is representative of the Hakuho style in its simplicity and in its application of the geometrical tradition. The figure displays a confidence in the perfection of man's power, a true model of austere classical beauty.

TEMPYO SCULPTURE:
THE CLASSICAL STYLE
AT ITS PEAK

The eighth century, in which the capital was established in Nara (710), saw the maturing of classical Buddhist art in Japan. There is a strong impression that the age of heroes had passed and had been replaced by one of consolidation and organization. The casting of the Great Buddha at the Todai-ji represents the megalomania of a culture at the apex of its development. Inherent in

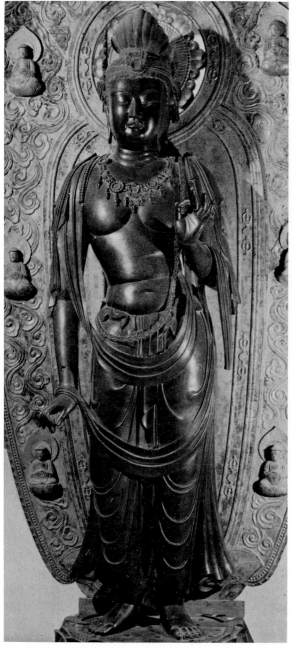

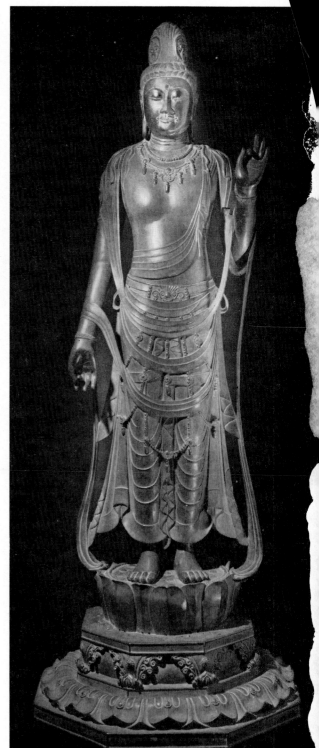

62. Gakko Bodhisattva of the Yakushi Triad. Bronze; height, 315.3 cm. Second half of seventh century. Kondo, Yakushi-ji, Nara.

63. Sho Kannon. Bronze; height, 188.5 cm. Second half of seventh century. Toindo, Yakushi-ji, Nara.

BUDDHIST PAINTING IN THE SYRO-GREEK STYLE

Decoration on rock wall surrounding the 53-meter Buddha. Bamiyan. Fourth to fifth century A.D.

...G USING THE WIRE-LINE TECH-

...dhist temple. Miran, Central

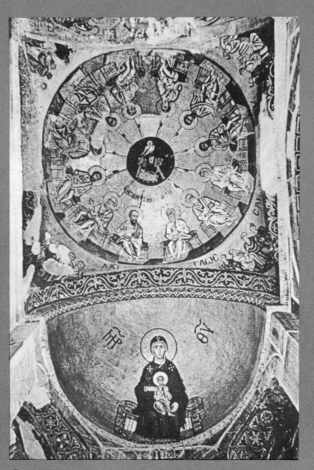

...LE IN WESTERN EUROPE

...e; detail of the Ada Group
...ntury.

GEOMETRICAL COMPOSITION OF ICONS

Byzantine dome; ceiling mosaic of Hagios Lukas. Eleventh century.

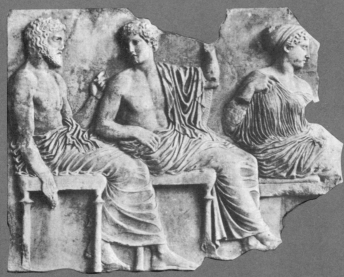

THE CLASSICAL HUMAN FIGURE

Poseidon, Apollo, and Artemis in the Parthenon reliefs.
Second half of fifth century B.C.

DRAP
CLASS

Athe
relief

SCHEMATIZATION OF THE CLASSICAL DRAPED FIGURE

Christ accompanied by two apostles. Psamatia site.
Fifth century A.D.

DIFFUSION OF THE CLASSICAL T
INTO BUDDHIST ASIA

Statue of a bodhisattva. Gand
Second century A.D.

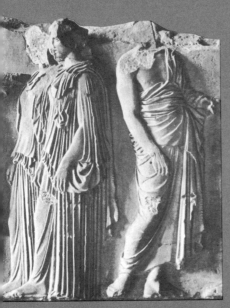

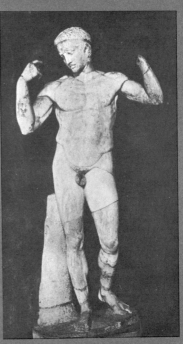

RY AND EXPRESSION OF CHARACTER IN THE
AL HUMAN FIGURE

an priests and virgins in the Parthenon
Second half of fifth century B.C.

MOTION IN A STATIONARY FORM IN
THE CLASSICAL HUMAN FIGURE: SUP-
PORTING LEG AND FREE LEG

Athlete, by Polyclitus. Original,
second half of fifth century B.C.

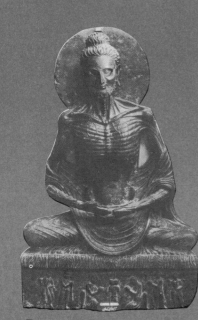

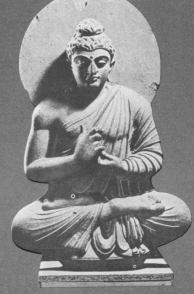

DIFFUSION OF NATURALISM IN
CLASSICAL SCULPTURE

Sakyamuni as an ascetic. Gan-
dhara. Second century A.D.

DIFFUSION OF CLASSICAL SCULPTURE:
SERENE SPIRITUAL EXPRESSION; PRO-
TOTYPE OF THE ALTERNATING WAVE
PATTERN IN DRAPERY

Seated Buddha. Gandhara. Third
century A.D.

"ASIANIZATI
GANDHARA

Head of
Kabul. Ea
tury A.D.

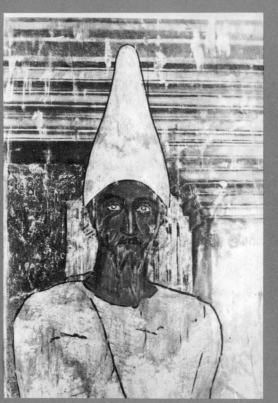

PAINTING: A
GH-RANKING

B.C. to first

SYRO-GREEK PAINTING: THE WIRE-LINE TECHNIQUE OF
THE ORIENTAL TRADITION COMBINED WITH THE GREEK
CLASSICAL STYLE

Mural of the Temple of Palmyra, Dura Europos.
First century A.D.

SYRO-GREEK-STYLE PAINT
NIQUE

Decorative mural of a B
Asia. Third century A.D.

EAST

manuscript of Cosmas Indicopleustes. Left, David with heavenly choir and gods
xth century.

THE SYRO-GREEK

Carolingian minia
gospel. Early ninth

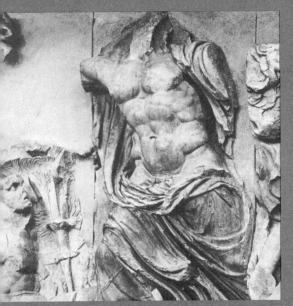

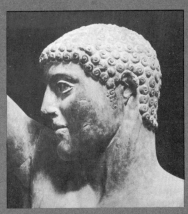

GEOMETRICAL COMPOSITION IN THE TRIPARTITE DIVISION OF THE TORSO: PROTOTYPE OF NI-O BUDDHIST GUARDIAN DEITIES

Zeus. Pergamum reliefs. Second century B.C.

PROTOTYPE OF CURLY HAIR IN THE BUDDHA IMAGE

Harmodius. Original, early fifth century B.C.

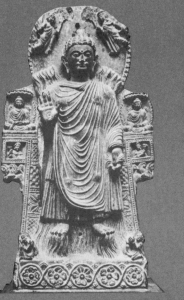

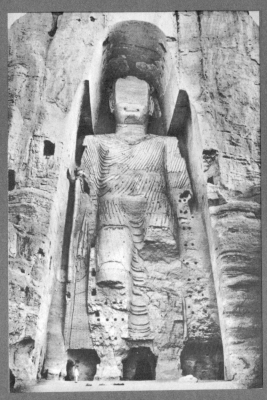

OF THE ...LE

bodhisattva. fourth cen-

BEGINNINGS OF "ASIANIZATION" OF THE GANDHARA STYLE: ELIMINATION OF NARRATIVE ELEMENTS; PROGRESS TOWARD TRANSCENDENTAL ICONOGRAPHY

Sakyamuni at Sravasti. Paitava. Third to fourth century A.D.

THE LARGEST GREAT BUDDHA: THE TRIUMPH OF CLASSICAL ANTHROPOMORPHISM

The 53-meter stone Buddha. Bamiyan. Fourth to fifth century A.D.

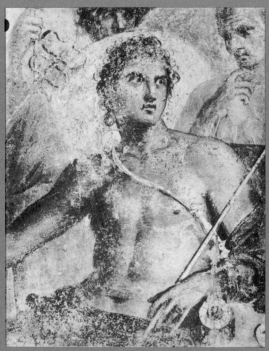

THE IDEALIZED HUMAN FIGURE

Achilles. Pompeii frescoes. First century B.C. to first century A.D.

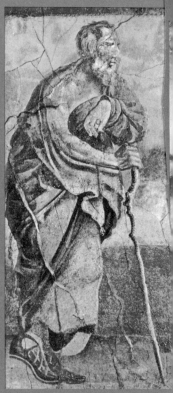

CHARACTERIZATION IN CLASSICA[L] FORERUNNER OF PAINTINGS OF PRIESTS

Old man of Boscoreale. First cent[ury] century A.D.

CIRCULAR COMPOSITION OF SMALL BUDDHA IMAGES AROUND CENTRAL IMAGE (Iranian type)

Decorative mural from a domed Buddha hall near Bamiyan. Fifth to sixth century A.D.

CIRCULAR COMPOSITION IN THE CHRIST[IAN]

Decorations in the Byzantine illumina[tion] of wind; right, the Creation. Origina[l]

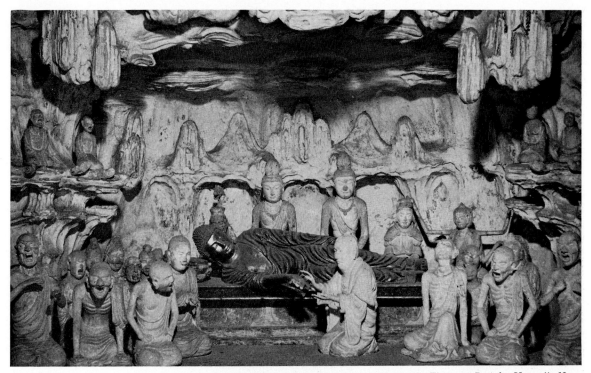

64. Buddha's Entry into Nirvana. Clay. 711. Five-story Pagoda, Horyu-ji, Nara.

such a time is the danger of destroying the harmony of the image of man that is always the nucleus of a classical style. Thus in the latter part of the classical period in Japan, new tendencies begin to be felt. A new age, exemplified by the wooden statuary of the Toshodai-ji, is emerging.

In addition to bronze and wood, sculpture of the Tempyo period (710–94) includes works in clay and dry lacquer: eventually these were to become the characteristic materials of the period. Because these new types of sculptures, derived from T'ang art, were suited to the representation of the variety of natural human postures and expressions, they were the favorite forms of the Tempyo period. Similar methods using plaster were common in decorative art in the ancient Greco-Roman world, and stucco techniques, which were one of the main factors that brought about the propagation of late Hellenistic art, spread eastward to the Buddhist

world of Gandhara and Central Asia, where they were adapted to produce the simple *deizo* ("mud image") form. It was this international technique that had enabled Greek-style Buddhist art to continue for so long. Using this ancient technique, Japanese classical art attempted to explore the human figure anew. When we reflect that the only clay or plaster statues from this period extant in western Europe are the Byzantine figures of saints found at Cividale in northern Italy, we are struck by the richness of the exploration of man in Tempyo art, although admittedly it owes a great debt to the Chinese art of the T'ang dynasty.

The groups of small clay figures in the five-story pagoda (Figs. 42, 64) and the guardian deities of the Chumon gate (Figs. 41, 66) of the Horyu-ji are thought to have been completed in 711, following the reconstruction of the temple. The clay statues of the deities Bon Ten (Brahma), Taishaku Ten

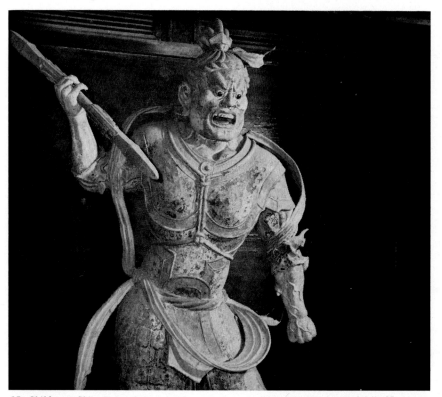

65. Shikkongo Shin. Painted clay; height, 167.5 cm. C. 733. Sangatsudo, Todai-ji, Nara.

(Indra), and the Four Celestial Guardians (all originally installed in the refectory) augment the Horyu-ji's rich collection of early-eighth-century works in clay.

The clay groups in the pagoda display a wide variety of postures, gestures, and facial expressions. Here the Tempyo sculptor employs his full repertoire of skills without restraint. With expressive vigor he reveals the psychology of the numerous realistic figures acting out their narratives—the Buddha's disciples lamenting his death (Fig. 64), for instance, or the dialogue between the layman Yuima (Vimalakirti) and the bodhisattva Monju (Manjusri; Fig. 42).

The guardians of the faith at the Chumon gate, with their brawny, swelling muscles, remind us of Roman soldiers or gladiators; the Four Celestial

Guardians, like the bearded versions at the Taimadera, evoke the awesome authority of fearfully armed T'ang generals. The repertoire of Buddhist sculpture is expanding.

The brightly colored clay figure of Shikkongo Shin (Vajradhara, a guardian deity of Buddhism; Fig. 65) is the "secret image" (one not normally displayed to the public) of the Sangatsudo at the Todai-ji. It is executed in naturalistic detail, down to the swollen veins of the neck and forearms of the angry god. Although the stance is one of fearsome rage, the movement of the body is handled with reticence, attention being concentrated on the fierce expression of the face. Such moralistic concern is the new task of the mature sculptor of the early eighth century. Characterization or psychological effect, achieved by gesture in the clay

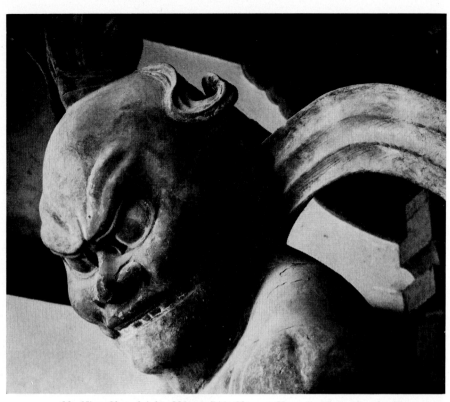

66. Ni-o. Clay; height, 330 cm. 711. Chumon, Horyu-ji, Nara. (See also Figure 41.)

figures of the Horyu-ji pagoda, is no longer suffi-
cient; sculptors were developing the skills necessary
to project an internal mental state.

This tendency toward introspection is clearly
discernible in the clay figures of Nikko and Gakko
(Figs. 67, 68) in the Sangatsudo of the Todai-ji, and
the Four Celestial Guardians (Figs. 69, 70) in the
Kaidan-in of the same temple. The observation of
the late art historian Naoteru Ueno that the eyes of
Nikko and Gakko are turned inward, in contem-
plation of their hearts, expresses precisely the spe-
cial character of Tempyo sculpture. By a subtle,
masterly differentiation, Nikko Bodhisattva is made
to symbolize the active life, while Gakko Bodhi-
sattva symbolizes the contemplative life.

The postures of the Four Celestial Guardians in
the Kaidan-in are less dynamic than that of the
Shikkongo Shin. Expressive elements are concen-
trated in the trunk and head; the legs are so simpli-
fied that one wonders how they can support the
tensed weight and motion of the trunk. The realisti-
cally represented armor is skillfully harmonized with
the wrathful faces. The portrayal of the human spirit
is so accomplished that one wonders whether the
ancient Greek theory of the four humors is not
echoed in the four faces. Man's feelings have rarely
been communicated as clearly as this—a universal
clarity achieved in the expression of human nature.

A similar achievement had already been made
in the Kofuku-ji's dry-lacquer statues of the Ten
Great Disciples (Fig. 43) and the Eight Supernat-
ural Guardians (Fig. 44). The task of expressing
the differing characters of the ten major disciples of
Sakyamuni gave the sculptor the opportunity to

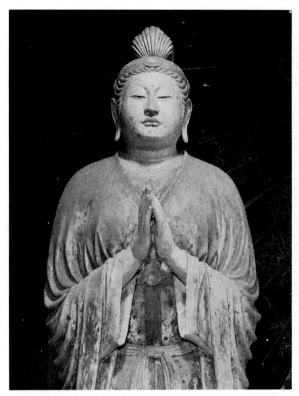

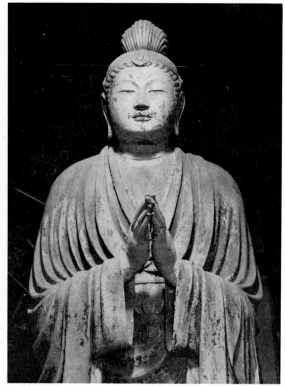

67. Gakko Bodhisattva. Painted clay; height, 224.4 cm. 742–46. Sangatsudo, Todai-ji, Nara.

68. Nikko Bodhisattva. Painted clay; height, 226.1 cm. 742–46. Sangatsudo, Todai-ji, Nara.

exercise his powers of psychological penetration and conceptualization. Here also, expressive representation of the body is suppressed in order to concentrate on facial expression and characterization. A rejoicing in youth crystallizes in the Ten Great Disciples the eternal image of happy Japanese youth.

The case is similar with the eight guardians. The psychology of the impressionable years of transition from boyhood to youth attracted the sculptor and underlies the solemn faces of the deities. Their penetrating gaze, as if looking at the outside world while at the same time deep in introspection, belies their mental restlessness. They seem here to be experiencing the mystery of human passion. Is it not astounding that this kind of exploration of man

should have been attempted? Compared with the mysticism of Asuka sculpture as an art of absolute conversion and faith, how redolent of human nature and how optimistic this religious art is!

As a new type of Buddhist image responding to man's need to contemplate the mystery of the Buddha, the Tempyo period has left us the Fukukenjaku (Fukukensaku) Kannon (Fig. 71) in the Sangatsudo. Perhaps due to the double base, the figure is too high and its warmly compassionate face cannot easily be seen from below. However, photographs taken from a higher position show us how closely the countenance reflects the attitude toward Kannon held in the time of Emperor Shomu (r. 724–49). Authority is not stressed. The face, perfectly at peace, is filled with dignity and

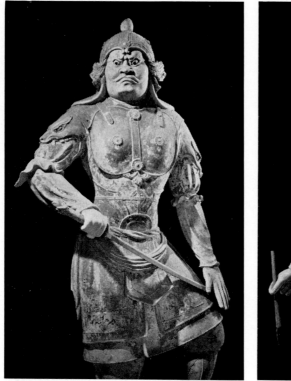

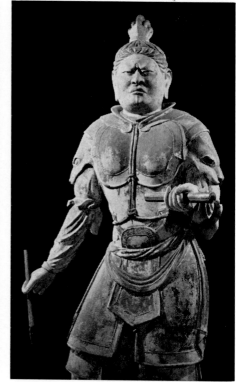

69. *Jikoku Ten, one of the Four Celestial Guardians. Painted clay; height, 178.2 cm. 742–46. Kaidan-in, Todai-ji, Nara.*

70. *Komoku Ten, one of the Four Celestial Guardians. Painted clay; height, 163.5 cm. 742–46. Kaidan-in, Todai-ji, Nara.*

compassionate love. The so-called third eye, placed vertically in the middle of the forehead, does not seem unnatural. Friendly yet full of a mystical greatness, the image is a masterly expression of Tempyo ideals.

Today only by reference to the Fukukenjaku Kannon and to the somewhat later Rushana (Vairocana) Buddha of the Toshodai-ji (Fig. 72) can we imagine what the original Great Buddha of the Todai-ji looked like. Emperor Shomu first vowed to build a Great Buddha in 743. After several abortive attempts elsewhere, construction was begun at the present site in 745. A magnificent dedication service was held seven years later.

Even for Emperor Shomu, who boasted that he possessed the wealth of the nation, the installation

of this 50-foot-tall gilt-bronze Buddha was a tremendous undertaking. The enterprise involved the whole nation. The revered Buddhist priest Gyoki collected donations throughout the country, while Shinto priests serving the Usa Hachiman Shrine offered prayers for the success of the venture. Part of a hill in the northeast section of Nara had to be cut away to make room for the huge statue and for the Great Buddha Hall housing it. The statue was gilded with gold leaf, providing a dazzling spectacle. On each petal of the lotus-blossom base of the statue, in the graceful, fine lines typical of the Tempyo period, is engraved a design representing the Rengezo Sekai (Padmagarbha Lokadhatu, "Lotus Treasure World"; Fig. 73), showing the Sakyamuni Buddha, as one of the 110,000 million

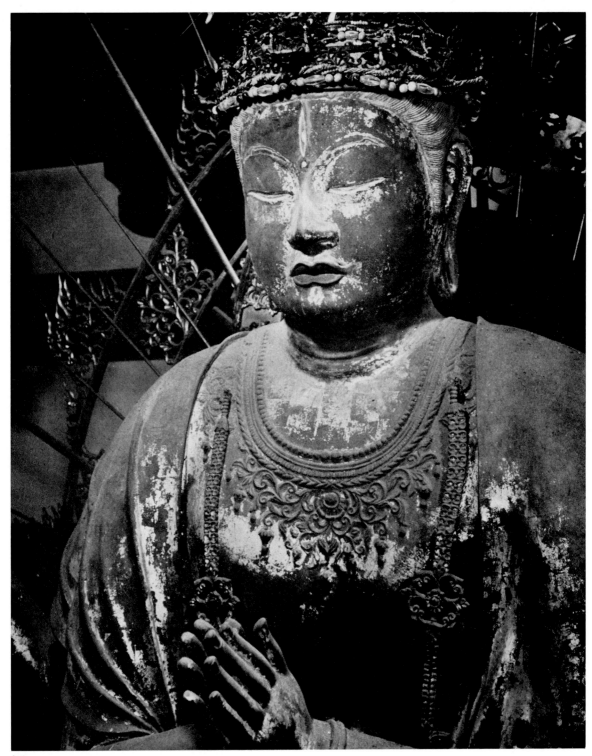

71. Fukukenjaku Kannon. Gilded dry lacquer; height, 360.6 cm. C. 746. Sangatsudo, Todai-ji, Nara.

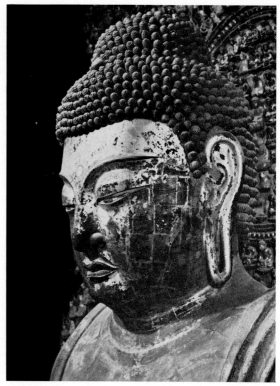

72. Rushana Buddha. Gilded dry lacquer; height, 303 cm. C. 759. Kondo, Toshodai-ji, Nara.

avatars of Rushana Buddha, surrounded by bodhisattvas. Rushana Buddha, the principal image of the official provincial temples established throughout Japan by edict of Emperor Shomu, is truly the ideal focus of the Buddhist empire.

As we have already noted, the idea of the Great Buddha image arose in the Gandhara region with Greek-style statues representing the Buddha in human form. At first the *stupa* and the image of the Buddha coexisted. The significance of the *stupa* as a symbol representing the relics of Sakyamuni preserved within it was reinforced by images that began to be installed as decorations, until gradually these idealized human figures came to dominate the *stupa*. These splendid Buddhist statues gained independence and no longer needed the *stupa*.

Nothing surpasses the magnificent Great Buddha of stone at Bamiyan in Afghanistan as an illustration of this process of development (see Foldout 3).

Here, just as earlier in the temples of the Gandhara region, the buddha hall and monks' quarters were distributed around a great *stupa*; the 115-foot stone Buddha, the 175-foot Buddha, and the four smaller seated images all have Buddha caves and monks' caves arranged around their Great Buddhas, indicating the position of the principal image of the great temple complex. In addition, the rock walls around the tallest statue and the seated images are decorated. On either side, beneath heavenly beings scattering flowers, are numerous figures on lotus-blossom bases, depicting the Buddha seated under the Bodhi tree (where he achieved enlightenment), while above are seated bodhisattvas, with Miroku in the center. The Bamiyan Great Buddha, thought to date from the fourth or fifth century, is extremely interesting in that it suggests the development of the Thousand Buddhas, Rengezo Sekai, Amida's Paradise, and other compositions used for purposes

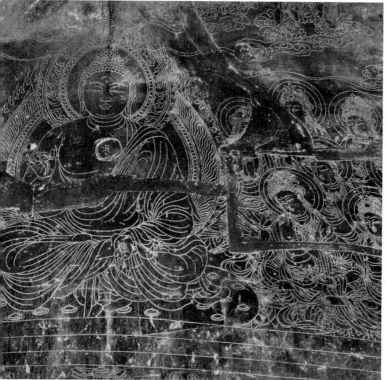

73. Lotus Treasure World, engraving on pedestal of the Great Buddha. Bronze. 757. Great Buddha Hall, Todai-ji, Nara.

74. Fukukenjaku Kannon. Wood; height, 173.2 cm. Second half of eighth century. Kodo, Toshodai-ji, Nara.

of contemplation. The Great Buddha represents the triumph of the classical image of man over the *stupa*.

However, both the gigantic image of the Great Buddha and the tiny figures of the Thousand Buddhas composition, with their opposite extremes of size, ignore the classical human scale and destroy the harmony that makes possible the intimate, human understanding of the ideal through the use of the human figure. Both the Great Buddha and the Thousand Buddhas themes are actually representations of the universe and attempt to present the abstract concept of the boundless universe by means of countless large and small images of man.

Corresponding to the Todai-ji and the Great Buddha of Bamiyan, in the Eastern Roman Empire

of the sixth century, Emperor Justinian I built the 165-foot-high Hagia Sophia in Constantinople. Its great dome was meant to symbolize the Christian universe. The interior was decorated with colorful marble and objects of gold, and the wall mosaics utilized cross and scroll motifs, but there was no representation of God, Christ, or the Virgin Mary. This reluctance to use the human image is found also in Islam; in contrast, the Buddhist world (like that of classical Greece), in which mountains, springs, wind, light, virtue, and vice are all represented through the human form, is a veritable deluge of human figures. To represent the gods of wind and thunder anthropomorphically is not uncommon, but at Bamiyan even the numberless universes take on human form. This is a startling

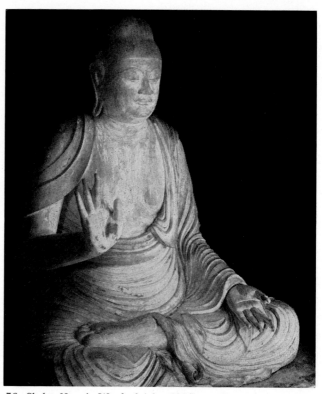

75. Standing Buddha. Wood; height, 179 cm. Second half of eighth century. Kodo, Toshodai-ji, Nara.

76. Shaka Nyorai. Wood; height, 105.7 cm. Second half of ninth century. Mirokudo, Muro-ji, Nara.

phenomenon, found in neither India nor China in ancient times.

When, where, and why did this inundation of human figures occur? And what were the consequences? One consequence, certainly, was the Two Worlds Mandala (Figs. 85, 98, 99) of the Esoteric Buddhist sects. As an explanatory diagram of the universe, a square, a circle, and some symbolic Sanskrit letters should have been sufficient. In this case, however, the diagram is crowded with beautiful Greek-style buddhas, bodhisattvas, and gods. Here we have the difference between Buddhist art, which accepted the classical human figure, and Christian art, which had to struggle against the proscription of the representation of the human figure stemming from the Jewish tradition. The

intimate connection between the image of the universe and the human image ultimately led to the establishment of a relationship between the image of the universe and the human individual.

Out of the academicism stressing technique and the intellectualism obsessed with doctrine—seen, for example, in the four buddhas of the Saidai-ji—into which Tempyo sculpture began to lapse, finally there arose in the wooden sculptures of the Toshodai-ji and the Daian-ji a tendency toward a bold, virile spirit. Some of the wooden statues of the Toshodai-ji (Figs. 74, 75), by emphasizing the curves and rhythms of a full and voluminous body, begin to hint at a potential for movement even though the figures are in static poses. Works appear with faces carved in strong relief, akin to Greco-

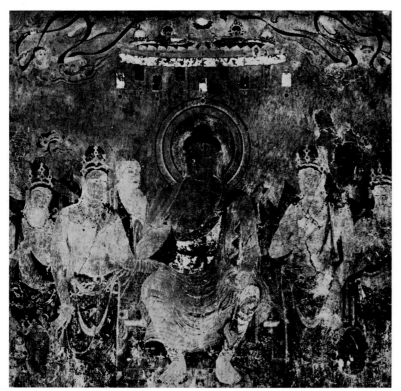

77. Paradise of Miroku. Mural; 314 × 255 cm. C. 700. Kondo, Horyu-ji, Nara. (Destroyed by fire, 1949.)

Roman models, and with flowing robes with fine folds, reminiscent of the drapery of classical statuary. We are already on the path that will lead to the Yakushi at the Jingo-ji temple (Fig. 87) and the seated Sakyamuni at the Muro-ji (Fig. 76).

THE RISE OF CLASSICAL PAINTING The murals in the Horyu-ji *kondo* (Figs. 39, 77) are the most outstanding works in the history of Japanese painting. It is no exaggeration to say that these works determined the basic mode of Japanese painting for a thousand years thereafter. The murals, together with the mandala at the Taima-dera (Figs. 108, 109), the embroidered Buddha of the Kanju-ji, and landscapes with figures preserved in the Shoso-in repository, such as the *Lady under a Tree* screen (Fig. 78), the so-called *Hemp Cloth Landscape*, and the *Persians Riding an Elephant* (decoration on a

lute; Fig. 79), reveal the efforts of Japanese painters to establish a classical style following the introduction of the T'ang style of painting. A fire in the Horyu-ji *kondo* in 1949 destroyed the murals, leaving intact only a few fragments of the large surfaces originally covered by the paintings. Fortunately, they had been extensively photographed earlier, so they have not been entirely lost to us.

On the walls of the *kondo* were depicted the paradises of the four buddhas Sakyamuni, Amida (Fig. 39), Yakushi, and Miroku (Fig. 77). Between them, there were eight representations of bodhisattvas, each occupying a single smaller wall section. Although these were Buddhist paintings, they did not illustrate legends from the life of the historical Buddha. Instead, they glorified four separate manifestations of the eternal Buddha, who is beyond the bounds of time, and transcended emotions and any suggestion of earthly activity.

78. Detail of Lady under a Tree. *Screen; colors on paper; 135×56 cm. 752–56. Shoso-in, Nara.*

However, this was not done symbolically as in the case of the didactic compositions of Asuka sculpture and painting. Each composition consisted of the principal buddha seated in the center under a colorful canopy, flanked by attendant bodhisattvas. Heavenly beings scattered blossoms from the sky, and the additional characters called for in each case filled the sides and background.

Depicted in a naturalistic manner derived from the tradition of Greek painting, the figures grandly proclaimed their universal existence. How amazed people of the time must have been to encounter buddhas and bodhisattvas not as intellectual symbols but portrayed realistically and set in a recognizable space! As in the Pompeii murals, the combination of warm red and yellow tones with cool blue and green ones must have given a fullness to the surrounding space, lending in turn a feeling of solidity to the flesh-colored human figures. The

folds of Amida's reddish brown robes were delineated by shading, and even the pattern on the back of his seat was clearly drawn. Ascetics and guardians of the faith, their faces and bodies full of character and giving an even deeper impression of realism, stood behind the buddhas and bodhisattvas. Those behind the Miroku on the north wall were particularly impressive. All the ascetics and guardians in attendance on the other buddhas also revealed their distinctive personalities through varied and individualized facial expressions and bodily postures.

In giving form to ideas, and using the human body to make people feel the actuality of concepts, this new style of Buddhist painting had deep and long-lasting effects on Japanese art. The facial expressions of the four buddhas, the bodhisattvas in attendance on them, and even the secondary guardians and ascetics became fixed, and particular

79. Detail of Persians Riding an Elephant, *decoration on the plectrum guard of a lute. Colors on leather; dimensions of painting, 40.5 × 16.5 cm. Eighth century. Shoso-in, Nara.*

expressions came to be associated iconographically with certain doctrines. Doctrines were clearly expressed in terms of the human form and were undoubtedly felt, discussed, and conceived as such. This marks the establishment of a classical style. The period of direct Greek inspiration of Buddhist art was over, but the idea of retaining the human figure as the basis of expression reflects the rich development of Buddhist art in central India; this art was further elaborated in T'ang China, whence it was introduced to Japan. The Horyu-ji murals, together with the Yakushi Triad dating from the same period, represent the first step in the realization of a classical style in Japanese Buddhist art.

The process of transformation into a naturalized Japanese style of painting is clearly traceable in the Heian period. The tendency of Japanese artists was to formalize the T'ang style while learning from it, and gradually to move away from the representation of objects in their concrete reality, introducing symbolic and decorative elements. The vivid effect created by the glowing faces of the bodhisattvas and beautiful women of T'ang paintings and the tactile quality of their sleek skin were effects that Japanese artists could not reproduce. When they tried, the result was stiff and awkward, like painted wood sculpture. But Japanese painters were attracted to formulas and symbolic shapes. Geometric stylization and concomitant spiritualization are among the special characteristics of Japanese painting.

CHAPTER THREE

The Formation of Medieval Art: The Heian Period

THE ART OF
ESOTERIC
BUDDHISM

Undoubtedly the distinguishing feature of the Heian period, which extended from the end of the eighth century to the late twelfth century, is the evolution of what might be called a purely Japanese art. The cessation in 894 of the practice of sending embassies to the T'ang court and the consequent decline in relations with the continent certainly must have been factors accelerating this development. In an island environment like that of Japan, close relations with the outside world are necessary to maintain a healthy equilibrium in artistic creativity. When such have waned in certain periods of history, Japanese art has begun to stagnate in abstract formalism or has fallen into a sensualism that is mistaken for realism.

In the first half of the Heian period, great religious leaders like Kukai (774–835), Saicho (767–822), Ennin (794–864), and other priests of the Esoteric Buddhist sects visited T'ang China with the object of mastering the ultimate teachings of Buddhism. This involved a great effort of intellect and will. The iconographic materials that they carried back to Japan were many, for their interests had extended beyond China to the Buddha's home-

land, India. The Buddhist painting of the early Heian period is markedly Indian in coloring, and the foreign element for a time grew even stronger than in Nara Buddhist art.

What is the "Japanese character" that eventually emerged? Is it represented by the women writers at the court? Or the *yamato-e* or *tsukuri-e* styles of painting? Actually, the tendency toward "Japanization" had appeared even earlier, at the time that Japanese art was growing more profound and esoteric. A new sensibility was emerging. This reaction against the classicism of the previous period was not exclusively Japanese but generally East Asian and Indian, as well. At the same time that Japanese art was developing a peculiarly national personality, artists elsewhere were creating spiritualizing, expressionistic arts that stressed national characteristics.

A new art is perceived in the Buddhist sculptures and paintings preserved in the To-ji (officially named the Kyo-o-gokoku-ji) and Jingo-ji temples in Kyoto. Early in the Heian period, the priest Kukai established a new Esoteric sect of Buddhism called Shingon (True Word), which made great use of art for didactic purposes. A powerful assertion of

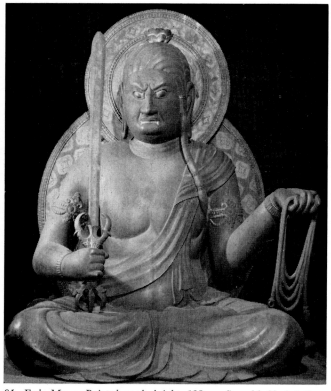

80. *Eleven-headed Kannon. Wood; height, 177.3 cm. Mid-ninth century. Kogen-ji, Shiga Prefecture.*

81. *Fudo Myo-o. Painted wood; height, 123 cm. Second half of ninth century. Mieido, To-ji, Kyoto.*

man had already appeared in late Nara art, in the Toshodai-ji sculptures, for example. Such Jogan-era (859–77) masterpieces of wood sculpture as the Yakushi Nyorai in the Jingo-ji (Fig. 87), the Eleven-headed Kannon in the Hokke-ji, Nara (Fig. 86), and the Togan-ji Kannon (now in the Kogen-ji, Shiga Prefecture; Fig. 80) were born of this tradition of a sculpture of will. Even works in dry lacquer, such as the Sho Kannon at the Shorin-ji, Nara Prefecture, follow the trend of the new age while continuing in the Nara tradition.

What is common to all these works is that the sculptors of the new age, impatient with Tempyo classicism and aware of an encroaching formalism, abandoned idealization in an attempt to bring the buddhas and bodhisattvas closer to themselves.

As Koichi Machida, whose special field is the sculpture of this period, has pointed out, a baroque style developed out of the classical, and an even more naturalistic use of the human figure was emphasized. There is a greater sensitivity to mass in human figures than in Tempyo works. The prominences of the chest, abdomen, and hips receive particular attention, and the sense of movement of the entire figure is intensified and reinforced by the flow of drapery. The union of expressionism and realism, and the investing of figures with religious sentiment, lends them great vitality. The sculptors of the Jogan era, having studied the naturalism of the Greco-Gandharan style assimilated by late T'ang sculpture and having completely mastered classical modes, finally

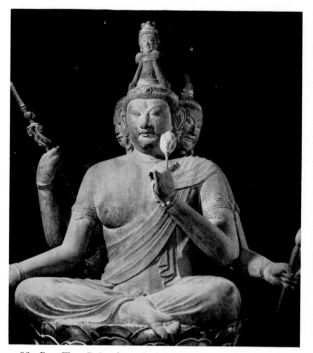

82. *Bon Ten. Painted wood; height, 100 cm. C. 839. Kodo, To-ji, Kyoto.*

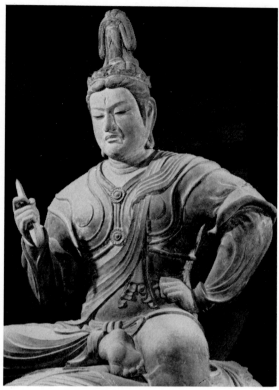

83. *Taishaku Ten. Painted wood; height, 105 cm. C. 839. Kodo, To-ji, Kyoto.*

developed Esoteric Buddhist sculpture into a richly sensual expression of the body reminiscent of Indian sculpture.

In both Tendai and Shingon Buddhism—the Esoteric sects—because their rigorous practices aimed at the attainment of identity between man and the Buddha (Dainichi Nyorai, or Vairocana Buddha, the fundamental essence of the universe), mandalas, Buddha images, and images of the angry deities were essential for creating an environment suitable for these practices. Whether Kukai himself actually produced any sculptures is not clear (although he did turn his hand to varied artistic endeavors), but there is no doubt that he taught the necessity of icons for the practice of esoteric religion. Indeed, he considered the painting or

carving of such images to be in itself an important religious act.

The Fudo Myo-o, one of the Five Great Kings of Light, in the To-ji lecture hall teaches the mystery of religious practice. In the Mieido of the To-ji there is a seated figure of Fudo Myo-o (Fig. 81) that is said to have been Kukai's personal devotional image. The severely carved face, in the aspect of rage, and the simply carved body, with its calm authority, enable us to imagine the Fudo Myo-o and buddhas as they once were in the no longer extant lecture hall of the Kongobu-ji on Mount Koya. Although simpler and more primitive than the To-ji statue, they must have had a great vigor. Their unsubdued power was probably the result of copying the central-Indian influence

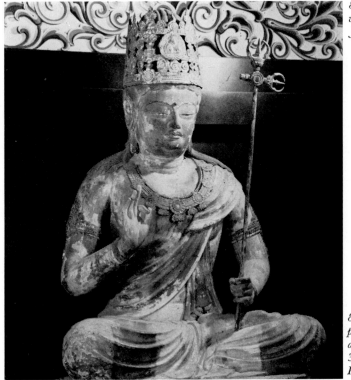

on late T'ang sculpture. The figures of the deities Bon Ten (Fig. 82) and Taishaku Ten (Fig. 83) show strong Indian influence, and their bodies, as well as those of the animals on the base, are realistically soft in form. The enraged, fiercely posturing images of the so-called Five Great Kings of Light, with flames on their backs, painted in lurid primary colors, overwhelmed the optimistic conception of man held by classical art. Drawing nearer to the world of human passions, they communicate the mystery of esoteric religion. These works represent an anticlassical art that uses the human figure to break through the boundaries of the image of man.

In contrast, the gold-colored Five Great Bodhisattvas in the lecture hall of the To-ji, with their soft, rounded bodies, offer gentle instruction in the world of contemplation. The mid-ninth-century Five Great Kokuzo Bodhisattvas (Fig. 84)

in the Tahoto of the Jingo-ji are calm, plump figures seated in tranquil meditation in typically Heian style. The plain coloring shows up clearly on the almost flat surfaces of the figures, and we are reminded of how important a role color plays in the new sculpture. The Nyoirin Kannon (Cintamanicakra) at the Kanshin-ji (Fig. 92) is so similar to these bodhisattvas that it has often been suggested that they are by the same sculptor. The skin color gives life to the full-bodied figure. Despite its supernatural, iconographic features, the statue retains the beauty of the female form. It is a living symbol of the compassion and protective love of Kannon. Among the sculptures of Kannon of the Jogan era, this Nyoirin Kannon and the Eleven-headed Kannon of the Hokke-ji and Togan-ji, cited earlier, give positive expression to the beauty of the female body. The Kanshin-ji statue might

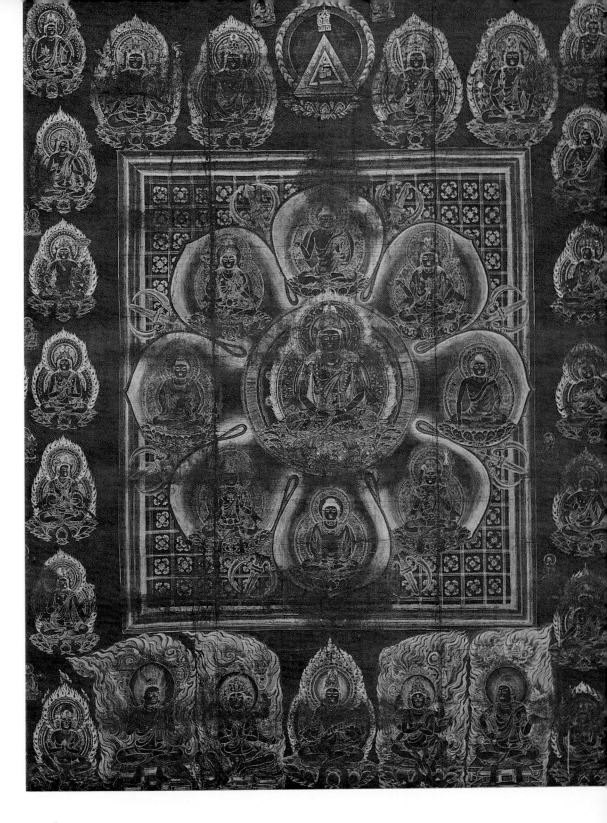

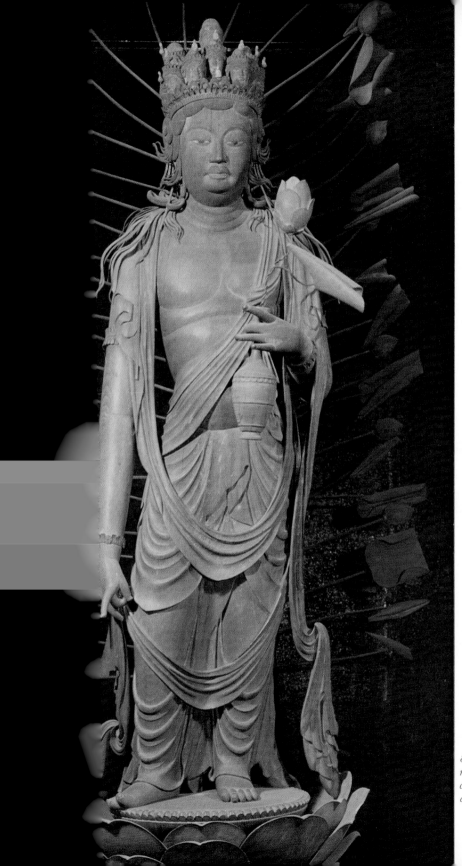

86. *Eleven-headed Kan-*
non. Wood; height, 99
cm. First half of ninth
century. Hokke-ji, Nara.

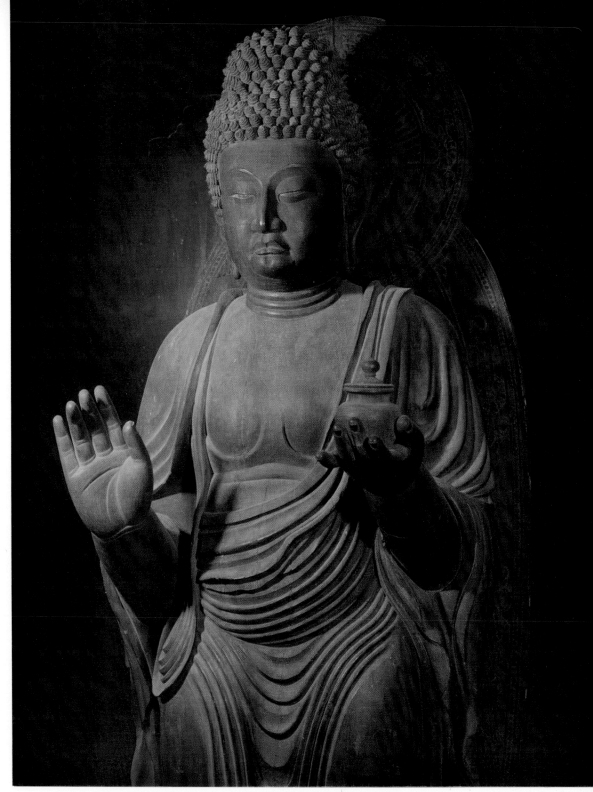

87. *Yakushi Nyorai. Wood; height, 170.3 cm. C. 802. Jingo-ji, Kyoto.*

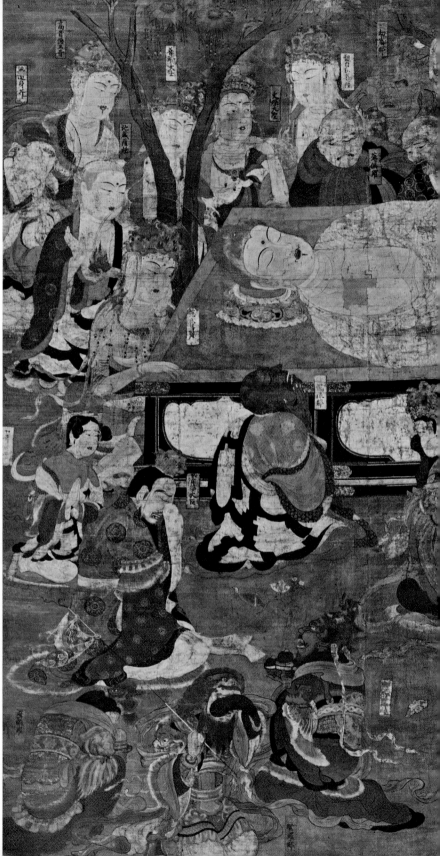

88. The Nirvana of the Bud-
dha. *Colors on silk; 267.5 × 271.2
cm. 1086. Kongobu-ji, Wakayama
Prefecture.*

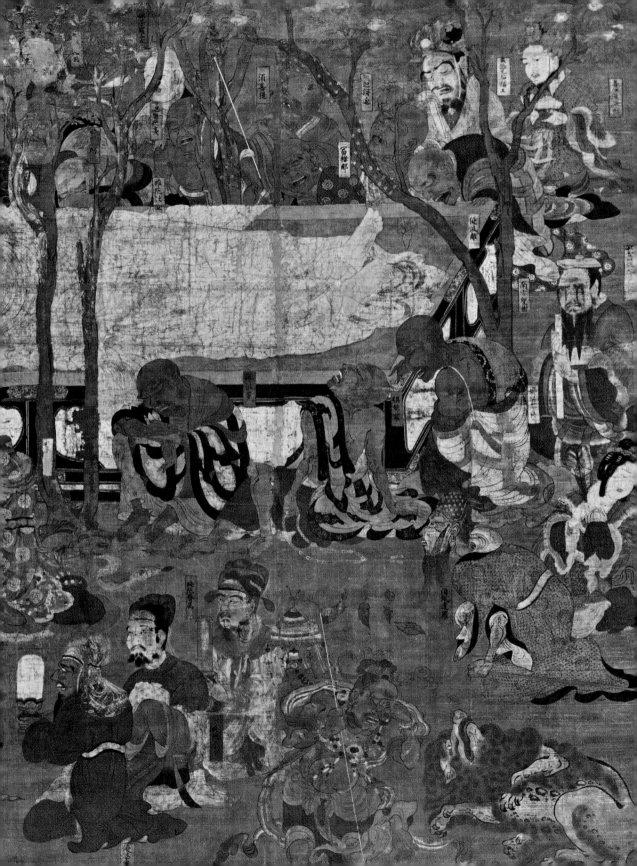

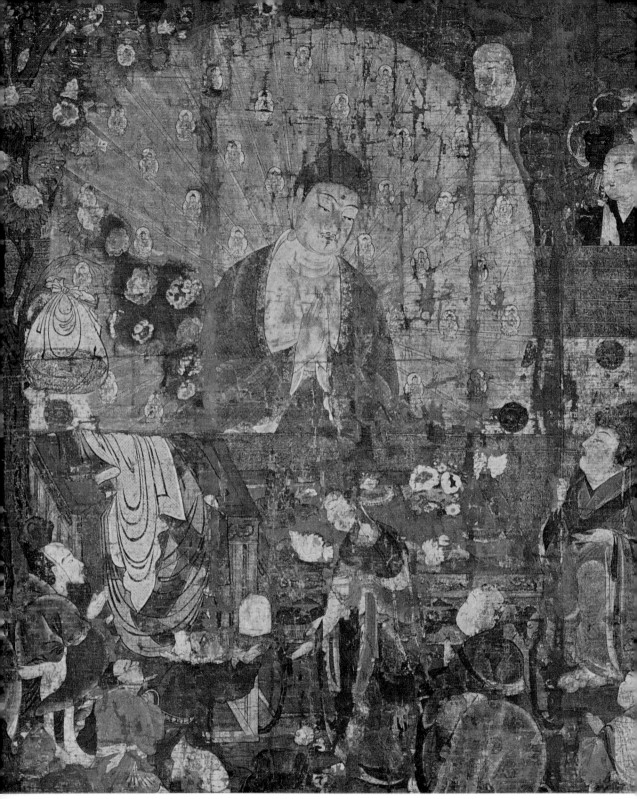

89. Sakyamuni Rising from the Golden Coffin. *Colors on silk; overall dimensions, 159.7 × 228.8 cm. Late eleventh century. Matsunaga Memorial Hall, Odawara, Kanagawa Prefecture.*

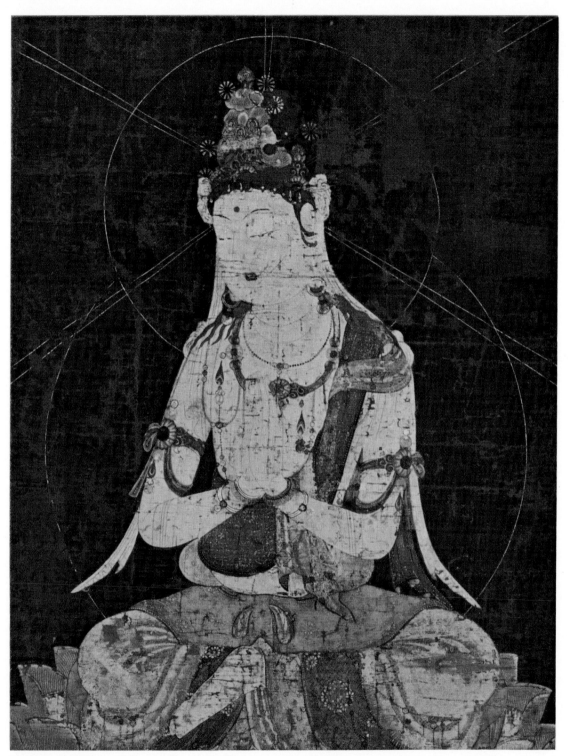

90. *Fugen Bodhisattva. Colors on silk; overall dimensions, 159.4 × 74.5 cm. First half of twelfth century. Tokyo National Museum.*

91. *Section from the* Amagimi *(Noble Nun) scroll of the* Shigi-san Engi Emaki *(Legends of Shigi-san Temple Picture Scroll).*
Colors on paper; height, 31.5 cm. Second half of twelfth century. Chogosonshi-ji, Nara.

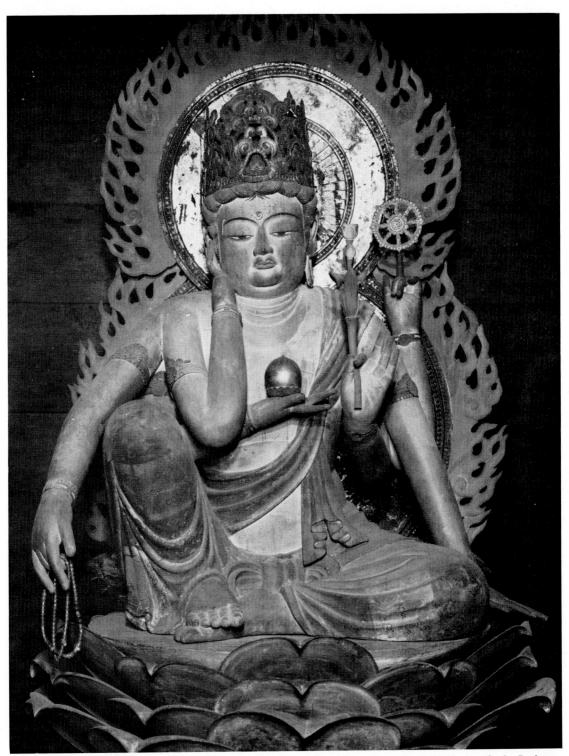

92. Nyoirin Kannon. Painted wood; height, 108.8 cm. C. 836. Kondo, Kanshin-ji, Kawachi Nagano, Osaka Prefecture.

93. *Gatten, one of the Twelve Celestial Beings. Colors on silk; 160×134.5 cm. First half of ninth century. Saidai-ji, Nara.*

94. *Nitten, one of the Twelve Celestial Beings. Colors on silk; 160× 134.5 cm. First half of ninth century. Saidai-ji, Nara.*

best be described as a representation of a "heavenly Aphrodite" purified by the ascetic's severity.

PAINTING IN
ESOTERIC BUDDHISM
The Twelve Celestial Beings in the Saidai-ji (Figs. 93, 94) have the monumental size of murals, the figures taking up the full width of the silk on which they are painted. The leisurely rhythms of the vermilion and black outlines surround the warm skin-toned areas of color. The influence of the Nara period is still strongly perceived, but there is a remarkable difference when compared with the Horyu-ji murals or the *Lady under a Tree* (Fig. 78) in the Shoso-in repository. In Nara painting, the human figure is built up of masses defined by distinct outlines. The new painting of the Heian period, more interested in compositions of flat areas of color, has taken the

first step toward polychrome painting. Sensitivity to color plays an important role in the new painting of Esoteric Buddhism.

The Yellow Fudo and Blue Fudo (Fig. 95) are two masterpieces of painting that exhibit a variation of form and color that is probably indicative of the differing conditions under which they were produced, as well as the differing interests of the periods from which they date.

The priest Enchin (814–91) of the Onjo-ji is said to have had a vision of a golden Fudo Myo-o while deep in meditation one day, and to have commissioned a painting of it. Since the resulting masterpiece may not be reproduced or even displayed, we must rely on the version in the Manju-in, Kyoto (Fig. 96), which is a copy of the original. The figure stands facing frontward. The brawny physique of the yellow body is vibrant with a powerful tension

95. Blue Fudo. Colors on silk; 203.3×148.8 cm. Second half of eleventh century. Shoren-in, Kyoto.

that contrasts with the softness of the pale yellow and vermilion robes falling from the figure's hips. The line is thick and strong-willed, like tensile steel, not the generous line of the classical painting of the Nara period. The muscles are tensed in a robust, determined manner. The gold-colored metal ornaments add to the severe mystical quality, and the figure as a whole exudes an authority that suggests a gilt-bronze statue.

The late-eleventh-century Blue Fudo of the Shoren-in, Kyoto (Fig. 95), represents a completely polychrome world of painting: leaping flames surround Fudo, who is seated in meditation on a rock. In the contrasts between motion and rest, light and darkness, the vivid colors communicate the mystery of religious practice. Whereas the Yellow Fudo utilizes the expressive power of a majestic form, in the Blue Fudo the painter pioneers a profundity of color that evokes subtle psychological nuances.

The painting style consisting of shapes filled out with color, which had already begun with the Twelve Celestial Beings of the Saidai-ji, came to fruition in the richly colored paintings of the eleventh and twelfth centuries. Works like the Five Great Kings of Light of the Daigo-ji and the Twelve Celestial Beings of the To-ji, with their voluptuous coloring, are typical of Esoteric Buddhist painting. It was at this time that a characteristically Buddhist style of painting was crystallized.

The Hokke-ji Amida, the Jingo-ji Sakyamuni, the Fugen in the Tokyo National Museum (Fig. 90), the Matsuno-o-dera Fugen—when we examine these richly colored paintings that were used as objects of worship, we realize that the form of Japanese Buddhist painting established at this

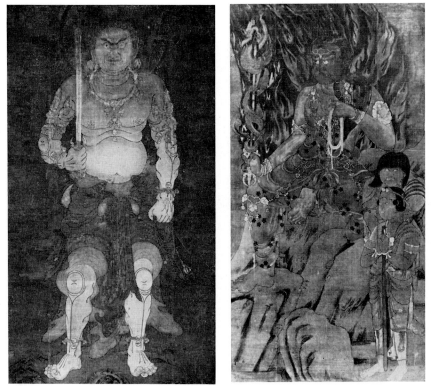

96 (far left). Yellow Fudo. Colors on silk; 178.1 × 80.3 cm. Tenth century. Manju-in, Kyoto.

97 (left). Red Fudo and doji attendants. Colors on silk; 165 × 95.8 cm. Ninth century. Myo-o-in, Mount Koya, Wakayama Prefecture.

time was to be used through the Kamakura and Muromachi periods. This style of filling areas with color, seen not only in Buddhist art but later also in the decorative paintings in Japanese castles and mansions, and in picture scrolls as well, was the governing technique of Heian painting until the rise of a linear style toward the end of the period.

MANDALAS The art of Esoteric Buddhism resists easy explanation, though the work of scholars like Takaaki Sawa has helped to reduce its mystery. A common feature of Esoteric Buddhist temples is a pair of facing mandalas on the left and right of the *kodo* (lecture hall). A mandala, literally "perfect completeness," is a large-scale schematic representation of all the modes of existence of Dainichi Nyorai, the ultimate source of the universe. Occasionally, for exceptionally important

ceremonies, representations of the various buddhas may be arranged on an altar in the lecture hall in imitation of the mandala form.

The Womb World (Taizokai) Mandala (Figs. 85, 99), has a round form representing an eight-petaled lotus blossom placed within a square in the center of the mandala. In the center of the lotus is Dainichi Nyorai, while the surrounding eight petals contain four buddhas alternating with four bodhisattvas.

On all four sides of this important central section, numerous buddhas and bodhisattvas are arranged in two or sometimes three rows, in the manner of the Thousand Buddhas—a Kokuzo group at the bottom, a Sakyamuni group at the top, a Kongo Rikishi group on the right, and a Kannon group on the left. Beyond this second section are further figures arranged in a single row in such a way that

98. *Diamond World Mandala. Colors on silk; 183.3×154 cm. Late ninth or early tenth century. To-ji, Kyoto.*

99. *Womb World Mandala. Colors on silk; 183.3×154 cm. Late ninth or early tenth century. To-ji, Kyoto.*

they adjoin those figures in the inner band with which they are iconographically associated—for example, next to the Sakyamuni group we have a Manjusri group, and next to the Kannon group there is a Jizo (Ksitigarbha) group. Finally there is an outer section containing two hundred or so small representations of various deities.

There is a gate on each of the four sides, giving the frame the appearance of a castle wall. The most important gates are the upper and lower ones. The upper gate is double, with the figure of Manjusri in the outer gate and Sakyamuni in the inner one. These portals are in the center of the Manjusri and Sakyamuni groups, respectively, and should perhaps be regarded as shrines rather than as gates.

Thus the Womb World Mandala organizes the various buddhas, bodhisattvas, and deities deployed in it into Hannya, Sakyamuni, Fugen, and Kannon

worlds, with Dainichi Nyorai in the center. It constitutes a schematic presentation of everything from the esoteric teaching of Dainichi Nyorai to a great system for the enlightenment of mankind. In brief, this symbolic diagram is one vast schema of Buddhist thought.

The Diamond World (Kongokai) Mandala (Fig. 98) serves a more practical function. Divided into nine smaller mandalas, it constitutes a kind of guide to esoteric studies and practices. Thus, whereas the Womb World Mandala is full of figures connected with the enlightenment of man, the Diamond World Mandala illustrates the principle of Dainichi Nyorai and methods of approaching him. It provides a kind of curriculum for the student monk.

From the point of view of art, it is surprising that complex philosophical and religious problems like the principles of Buddhism, cosmology, and human

100. Ryuchi, one of the Eight Patriarchs of the Shingon Sect. Colors on wood; 951. Five-story Pagoda, Daigo-ji, Kyoto.

existence should be schematized in this way. Narrative paintings and relief carvings had been made to illustrate the episodes and legends connected with Sakyamuni's life, from his birth to his entry into nirvana. The classical style of Greek art had also depicted this kind of subject matter in naturalistic scenes. Some tales of the Buddha, particularly those having special doctrinal significance, were transformed from illustrations of the traditional biography to illustrations of doctrine and ritual. One of the stories about miracles performed by Sakyamuni, the Miracle at Sravasti (see Foldout 3), after undergoing many changes in the Gandhara region, gave birth to a composition that led eventually to the Thousand Buddhas and Amida's Paradise compositions.

This tendency to exclude narrative elements and create a scheme of ideas that transcends time and space in effect carries the search for idealization characteristic of classical art to its extreme. Beginning with the creation of sculptures of Sakyamuni as ideal images, the interior and the walls of pagodas and buddha halls were filled entirely with innumerable images of the Buddha. It came to be used as the unit in a grand continuous pattern, producing both the Thousand Buddhas composition and circular patterns (see Foldout 2). This was the ultimate development of the Iranian type of decorative pattern. The Thousand Buddhas composition and the circle motif are the basic units of composition of the mandala.

The oldest extant version of the Two Worlds Mandala, a combination of the Womb World and Diamond World mandalas, is that preserved in the To-ji. We may conjecture whether this is the most accurate transmission of the design Kukai received

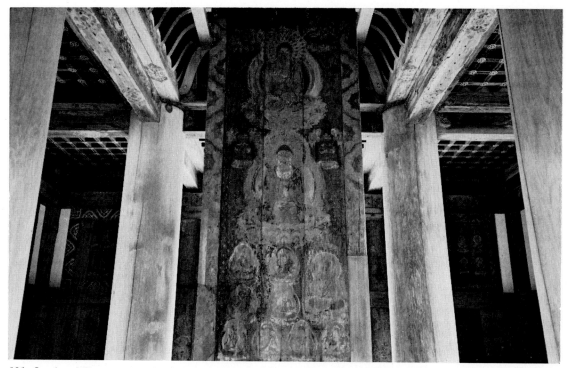

101. Interior of Five-story Pagoda. Dimensions of painted board encasing central pillar, 261.5×70 cm. 951. Daigo-ji, Kyoto.

from the monk Hui Kuo of the T'ang temple Ch'ing-lung-ssu. The T'ang style is apparent in the rich coloring and shading. The buddhas, the vases, even the scroll motifs all have a graceful, classical expressiveness, with delicate, sensuous coloring. In contrast, the Kojima-dera version of the Womb World Mandala (Fig. 85), thought to date from between 999 and 1004, shows an extremely refined taste, the figures being drawn in delicate, graceful lines of gold and silver on indigo damask, inviting contemplation of the mystical world of the absolute.

The nucleus of Esoteric Buddhist art is the cosmic image, the mandala. The architectural ideal was the mandala hall, which in itself was a mandala. Thus in Esoteric architecture, apart from the lecture hall and small halls used for training purposes, the mandala hall is of central importance. It differs from the early pagoda and *kondo*. In the case of

the To-ji, buildings of the older type were first constructed as a matter of custom, and Kukai then organized them into lecture and mandala halls. Part of the five-story pagoda was made into a mandala hall. It contains the Two Worlds Mandala, and eight paintings of patriarchs decorate the wall panels (Figs. 100, 101). However, when Kukai established a religious center on Mount Koya, he built two circular structures—the North and South pagodas—specifically to house the Diamond World and Womb World mandalas, with the lecture hall between them.

NATURE IN RELIGION Both Saicho, founder of the Tendai sect, and Kukai located the centers of their sects in temples on mounts Hiei and Koya, respectively. Both the Tendai and the Shingon sects were pantheistic in that man,

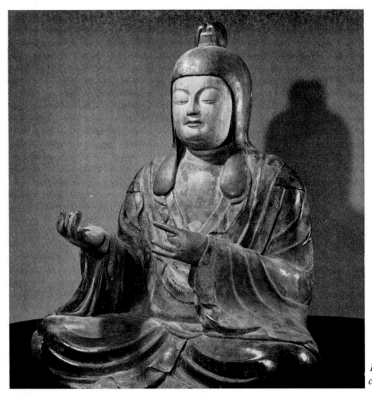

102. Shinto goddess. Painted wood; height, 115 cm. Ninth century. To-ji, Kyoto.

animals, and plants were all viewed as manifestations of the Buddha. The contemplative religious practices aiming at identification with the essential nature of the buddhas and bodhisattvas deepened the individual's mental faculties and consciousness of self. We can see the reflection of such attitudes in the Buddhist painting of the Heian period. To regard the phenomena of nature as harboring the ultimate principle of Dainichi Nyorai awakens a profound sensitivity toward nature. In Buddhist sculpture and painting this sensitivity is manifested as a deep interest in the human body and a delicate sense of color. Gradually it comes to be directed toward the charms of nature as well.

Early Shinto beliefs grew out of religious awe and reverence toward the natural world. The practices of Esoteric Buddhism raised this primitive nature worship to a higher plane, transforming it into a religion of mountain worship that through rigorous training and will power aimed at participation in the mysteries of Dainichi Nyorai hidden in nature. Peculiarly Japanese aspects of this mountain worship were the *tachiki* Kannon (carved from one living tree), *natabori* buddhas (rough wooden sculptures hewn with an ax), and the *magai* buddhas (buddha images incised in rock) made by adherents as testimony of their faith. In a strange metamorphosis, Shinto deities were incorporated into the Dainichi Nyorai pantheon; not only were they given Buddhist names, but images of the gods began to appear in shrines connected with the Shingon sect. An example of this Buddhist representation of Shinto gods and goddesses is a group at the To-ji (Fig. 102). Much of the later sculpture of the native deities does not derive from the Buddhist sculpture of the Nara and Kamakura periods but rather from

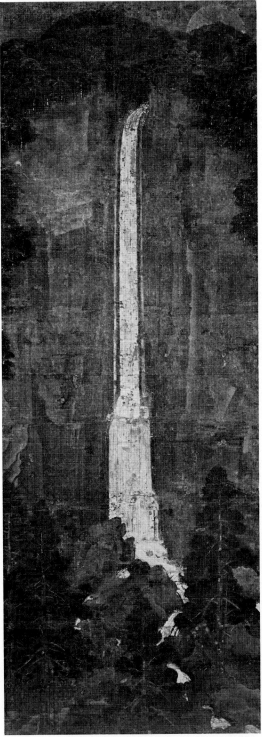

103. Nachi Falls. *Colors on silk; 159.4 × 57.9 cm. Late thirteenth century. Nezu Art Museum.*

the painted Shingon sculpture of the early Heian period.

In time, Shinto shrine mandalas (Fig. 118) began to appear and remained popular until the Kamakura period. In these the natural surroundings of the shrine themselves are a manifestation of the godhead. The mysticism and severity of the painting of the Nachi Falls (Fig. 103), a landscape with the waterfall itself as the object of worship, derive from this background.

THE ART OF PURE LAND BUDDHISM Another important development of the Heian period was the flourishing of the arts associated with the widespread belief in Amida's Paradise (Jodo, "Pure Land") that grew out of the Tendai sect of Esoteric Buddhism. Indications of faith in Amida's Pure Land

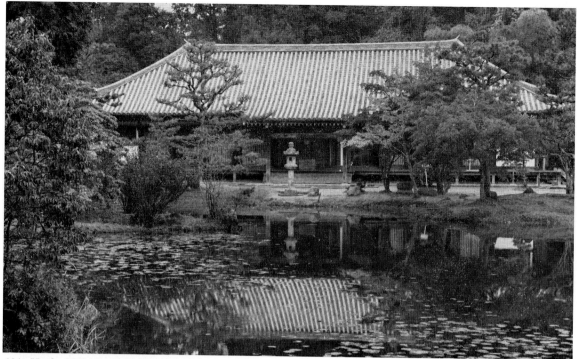

104. Hondo. 1107. Joruri-ji, Kyoto Prefecture.

had already appeared by the latter half of the seventh century. Examples of this are the Amida Triad of Lady Tachibana's Shrine (Fig. 60) and the tapestry representation of Amida's Pure Land woven as an offering for the repose of Emperor Temmu's spirit. Later, in the second half of the eighth century, Dowager Empress Komyo installed three statues of Amida in the Amida Hall that she had built at the Hokke-ji. The interior walls were decorated with small figures of heavenly musicians floating among clouds, and the interior of the hall itself was intended as an earthly re-creation of the Pure Land.

The Hokke-ji Amida Hall was executed in a decorative style of classical conception. The Phoenix Hall (Fig. 105) at the Byodo-in temple at Uji, near Kyoto, continues this tradition in a more complex form. The Hokke-ji Amida Hall was a rectangular seven-bay building with a colonnade along the front. It was wider than it was deep and was based on the *kondo* formula of the Nara period. This ancient form continued in general use in the Heian period and is thought to have been typical of large Amida halls. The only extant example is the main hall of the Joruri-ji in Kyoto (Fig. 104), dating from 1107. This is an eleven-bay rectangular Amida hall facing a pond. Nine sculptures of Amida are arranged in a row, and originally they were worshiped from the colonnaded veranda. The Amida Hall of the Hojo-ji, built by Fujiwara Michinaga (966–1027) in 1020, was also an eleven-bay, rectangular hall built beside a pond and housing nine Amida statues. The hall at Emperor Shirakawa's (r. 1072–86) Hossho-ji, dating from 1077, was another example. As can be seen from these examples, quite a number of these imposing

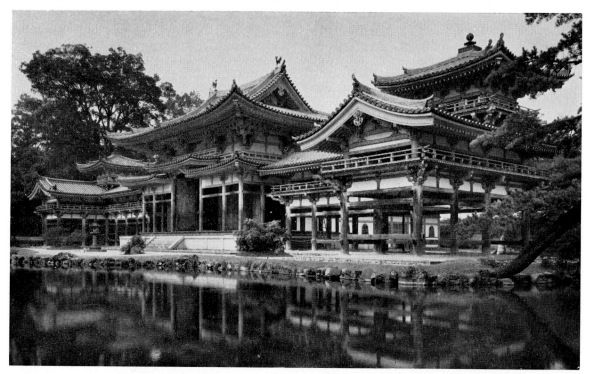

105. Phoenix Hall. 1053. Byodo-in, Uji, Kyoto Prefecture.

Amida halls were built in the period of rule by cloistered or retired emperors in the eleventh and twelfth centuries. This use of the ancient form does not signify the mere continuation of an old tradition. Rather, just as Kamakura sculpture later tried to re-create the style of the Nara period, we can perceive here a spirit of conscious revival. By the thirteenth century, the tendency had developed into the construction of the large Sanjusangendo (thirty-three-bay hall) of the Rengeo-in temple in Kyoto.

Still another type of Amida hall was developed during the Heian period. This is a condensed form, consisting of an enclosed three-bay square space and based on the Sammaido (*samadhi* hall) of the Tendai sect. On the four central pillars supporting the *oriage*-type ceiling (representing a cupola) are painted the Buddha images of a mandala. It is in

effect a mandala hall with an image of Amida placed at its center. Examples are numerous— Hokai-ji (second half of the eleventh century), Hokongo-in (twelfth century), the Konjikido of the Chuson-ji (twelfth century). These structures parallel and bear witness to the rise of a new Amida-based faith in the context of practices described in the Tendai meditation manual *Maka Shikan* by the sixth-century Chinese priest Chih-i, third patriarch of the T'ien-t'ai (Tendai) sect.

The Phoenix Hall of the Byodo-in at Uji is the highest expression of the Pure Land Buddhist art of this period. The regent Fujiwara Yorimichi (994–1074) converted his Uji villa into a temple, built an Amida hall—known today as the Phoenix Hall, or Ho-o-do—installed in it an image of Amida (Fig. 106) by the sculptor Jocho, and in 1053 dedicated the temple in a grand ceremony.

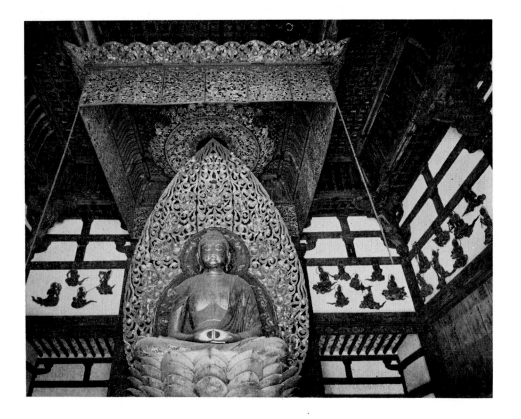

This is the only remaining example of the many Buddhist temples built during the so-called Fujiwara period (967–1068), when the Fujiwara family held political ascendency at the imperial court. With Jocho's masterpiece in the center of the hall, architecture, painting, and sculpture were unified in what was described at the time as a paradise re-created on earth.

The central Amida hall is of the three-bay, square Tendai type, with one principal image. The building faces a pond, with galleries projecting to left and right, the pillars of these wings joining those of the colonnade at the front of the hall. The structure as a whole blends harmoniously with the surrounding garden. It has been suggested that the Phoenix Hall echoes the palaces and pavilions of the Pure Land depicted in the mandala at the Taima-dera. The architect's ideal in this building

was apparently the light airiness of an aristocrat's residence rather than the heavy solemnity of temple architecture. With its modest dimensions, varied roofs on the separate sections, and use of curved lines, the impression is one of a human rather than a godlike scale.

Jocho's statue dominates the interior of the Phoenix Hall (Fig. 106) with its concentrated, mystical expressiveness. Amida's compassion quietly spreads and pervades the surroundings. The modeling of the body is unobtrusive; its gently curving surfaces are almost flat. Behind the gilded principal Buddha, a great mandorla rises to the ceiling. Between the base, decorated sumptuously with mother-of-pearl, and the great square-plus-circle double canopy of open scrollwork in gleaming silver and gold, a square-bounded space has been created at the very center of the Amida Hall. At

◁ 106. Interior of Phoenix Hall. Byodo-in, Uji, Kyoto Prefecture.

107. Raigo *of Amida and celestial host, detail from door painting. Colors on wood;* 77× 58 *cm. 1053. Phoenix Hall, Byodo-in, Uji, Kyoto Prefecture.*

one time, four long gold curtains and nets were suspended from the canopy, so that the effect must have been more striking. The mandorla, canopy, and base play an important role, since they create a world of mysterious splendor around the figure of Amida. In contrast, the vegetable ornamentation outside this space, on pillars, ceiling, and elsewhere, is of an earthly kind, in green and vermilion, adorned with colored figures of heavenly musicians.

The four great doors, the screen behind Amida, and the wood-paneled walls on either side are decorated with paintings depicting Amida's descent to welcome the believer to his paradise (Fig. 107). The pictures are not well preserved, and only a few fragments are clearly discernible. They show people gathered at a shrine, and birds and animals in a variety of landscapes. The natural scenery is a very

important feature of these paintings, for it is pervaded by a kind of religious quality that may perhaps be described as an awareness of the transience of life. The paintings on the doors are the oldest, and may date from the founding of the temple. The screen and walls are in a somewhat later style, and may date from the thirteenth century, when the hall was renovated. The front of the screen depicts a palace. The scenes showing crowds of people are done in a rough hand, but the brush work is vigorous and the warm colors in which the figures are painted recall such masterpieces of the narrative-picture-scroll genre as the *Ban Dainagon Ekotoba* (Fig. 125) and the *Shigi-san Engi Emaki* (Fig. 91).

A work illustrating Amida's Paradise had appeared as early as the Nara period: the Taima Mandala (Fig. 108) includes all the aspects of such

ART OF PURE LAND BUDDHISM · *101*

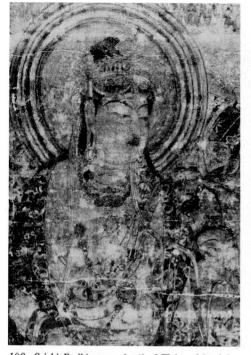

108. *Seishi Bodhisattva, detail of Taima Mandala. Silk tapestry; 391×397 cm. Second half of eighth century. Taima-dera, Nara Prefecture.*

109. *Taima Mandala, by Keishun. Colors on silk; 374×382 cm. Bunki-era copy, 1502. Taima-dera, Nara Prefecture.*

a composition, complete with renditions of the story of Lady Idaike, the Thirteen Ways to Meditate, and the Nine Categories of Rebirth in Paradise, depicted along the left, right, and bottom edges of the work. Of particular interest in the case of the Phoenix Hall door paintings, however, is the fact that the scenes of rebirth in Paradise are deliberately combined with landscapes in the *yamato-e* style. These "Rebirth in Paradise" scenes including landscapes in the *yamato-e* style are especially interesting because elements in the landscapes of several of these small scenes have been associated with particular months of the year, indicating that the natural scenery of the picture may have been derived directly from the *shiki-e* (seasonal pictures) and *tsukinami-e* (monthly pictures) adorning screens in the palaces and mansions of the Heian period.

THE RISE OF YAMATO-E

From the mention of such paintings as *Screen of Sages, K'un Ming Lake Screen,* and *Rough Sea Screen,* it is inferred that *kara-e* (literally, "Chinese paintings") were popular at the court during Nara and Heian times. The landscape screen until recently in the To-ji (Fig. 110) offers a glimpse of this style, revealing it to be a continuation of the Nara classical style, which in turn had developed out of T'ang painting. Figures and objects are portrayed in a naturalistic manner, with the feeling of depth and of surrounding space well conveyed. Although line, shading, and coloring are well balanced, the function of line is dominant, with shading and coloring secondary.

Decorative painting, which became popular at the tenth-century court, was termed *yamato-e,*

110. Detail of senzui byobu (landscape screen). Colors on silk; dimensions of each panel, 146.1 × 42.6 cm. Second half of eleventh century. Kyoto National Museum.

"Japanese painting," in view of the fact that it took Japanese themes for its subject matter, to distinguish it from *kara-e* with its Chinese subjects. Both are, of course, styles of Japanese painting. But as the *yamato-e* genre gradually took on a definite character, the term, originally referring to the subject matter, came to indicate the style, as well.

As in the case of Buddhist painting, three-dimensionality was suppressed in favor of composition in terms of flat surfaces, so that in mid-Heian (tenth century) decorative painting, flat areas, and coloring in particular, assumed precedence over line. There is also a shift away from active, positive modes of expression to a more passive suggestiveness. Since area composition and color are stressed, this style is particularly well suited to the architectural use of decorative painting. This accounts

also for the successful use of fine-cut gold and silver leaf as a background for paintings. It was rather the "naturalistic illusionism" of the ancient classical style, as seen in the *Persians Riding an Elephant* (Fig. 79) on a lute in the Shoso-in, with its subtle chiaroscuro techniques and its treatment of landscape in perspective, that went against the essential nature of painting and was fated to give way sooner or later.

Many paintings produced in the Heian court environment exhibit the special technique of rendering features in an abbreviated manner known as *hikime-kagihana* (literally, "slit-eyes, hook-nose"; Fig. 111). The influence of this style extended well beyond the Heian period. Although the term refers specifically to the highly stylized, impassive representation of human features, the technique is

111. Detail of frontispiece of "Yakusoyu-bon" chapter of Kuno-ji Sutra.
Colors on paper; 25.5×21.3 cm. C. 1141. Muto Collection, Hyogo Prefecture.

accompanied by conventionalized costumes and also by a diagonal, downward-looking perspective of houses with roofs removed so that interior scenes could be viewed (Fig. 130). Clouds, mist, hills, streams, and waves are all likewise reduced to conventional formulas. This style is executed in a geometrical or formulaic fashion in which a scene is built up by combining stylized forms in various ways.

Since the painter attempts to express his feelings in a manner analogous to the terse *waka* verse form, by intensive use of a deliberately limited vocabulary, it has been suggested that the style may have originated in pictures taking their subject matter from *waka* or the *uta-monogatari* (poetic romances). Whether this is so or whether the style originated

in applied-art painting is open to debate, but the artists who illustrated the *Genji Monogatari Emaki* (The Tale of Genji Picture Scroll), the *Nezame Monogatari Emaki* (Tale of Nezame Picture Scroll), the *Murasaki Shikibu Nikki Emaki* (Diary of Lady Murasaki Picture Scroll), and other narrative scrolls managed within this limited repertoire of conventionalized techniques to suggest a wide range of emotions, actions, and space. They tried to depict the psychological implications of an episode, availing themselves of their knowledge of the poet's or author's intentions. The most successful examples of this are the illustrations of the "Yugiri" and "Yadorigi" chapters of *The Tale of Genji,* in which the psychology of the protagonists resonates on a monumental scale.

112. *Portrait of Myoe Shonin, by Enichibo Jonin. Colors on paper; overall dimensions, 146 × 58.8 cm. 1230. Kozan-ji, Kyoto.*

113. *Shinto goddess Tamayori-hime no Mikoto. Painted wood; height, 82.7 cm. 1251. Yoshino Mikumari Shrine, Nara Prefecture.*

114. Eki Doji, one of the Eight Attendants of Fudo Myo-o (Hachi Dai Doji), by Unkei. Painted wood; height, 98.7 cm. C. 1198. Kongobu-ji, Wakayama Prefecture.

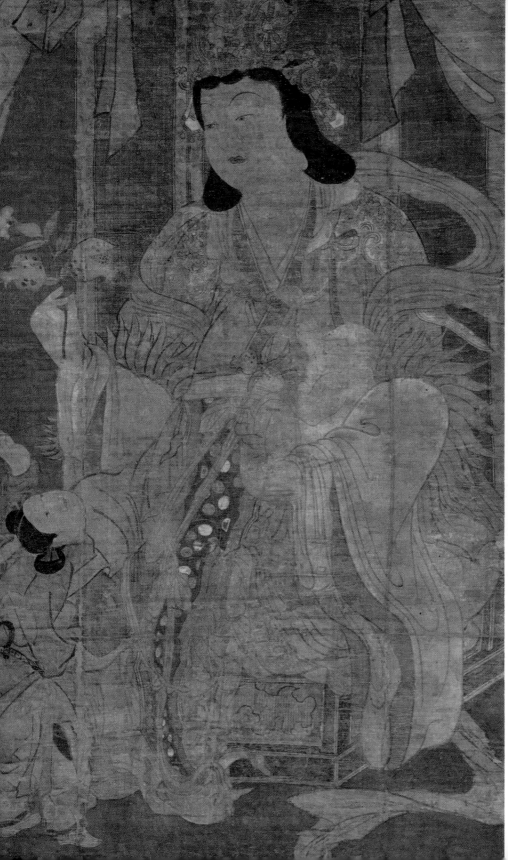

115. *Kariteimo (Hariti). Colors on silk; 130 × 78 cm. Second half of twelfth century. Sambo-in, Daigo-ji, Kyoto.*

116. *Kichijo Ten. Painted wood; height, 90 cm. 1212. Joruri-ji, Kyoto.* ▷

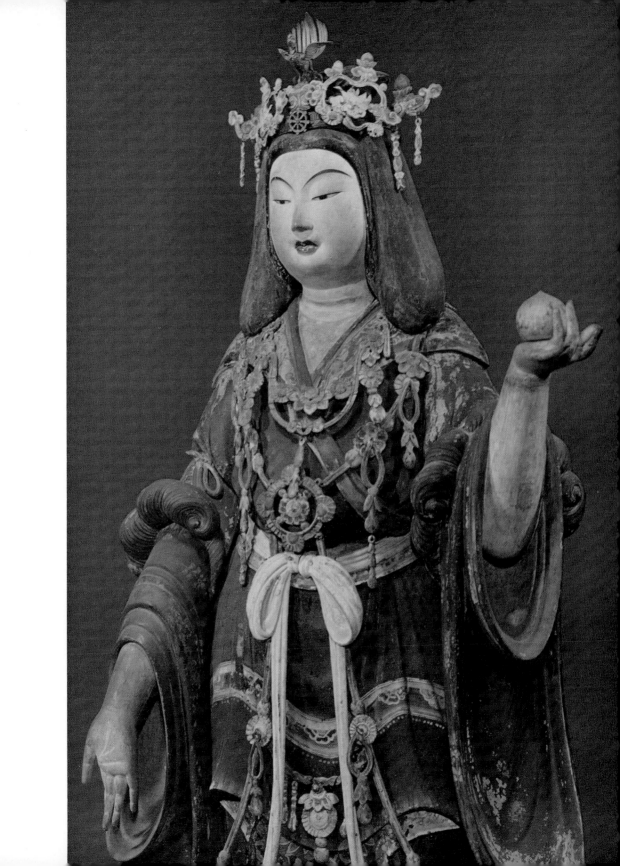

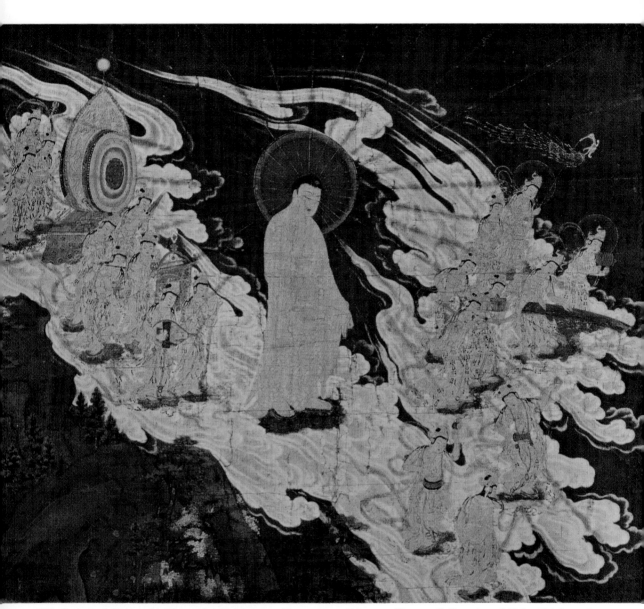

117. *Descent of Amida with Twenty-five Bodhisattvas;* Haya-raigo. *Colors on silk; overall dimensions, 145.1×154.5 cm. Late thirteenth or early fourteenth century. Chion-in, Kyoto.*

118. Kasuga Shrine Mandala. Colors on silk; 109 × 41.5 cm. 1300. Yuki Collection, Osaka.

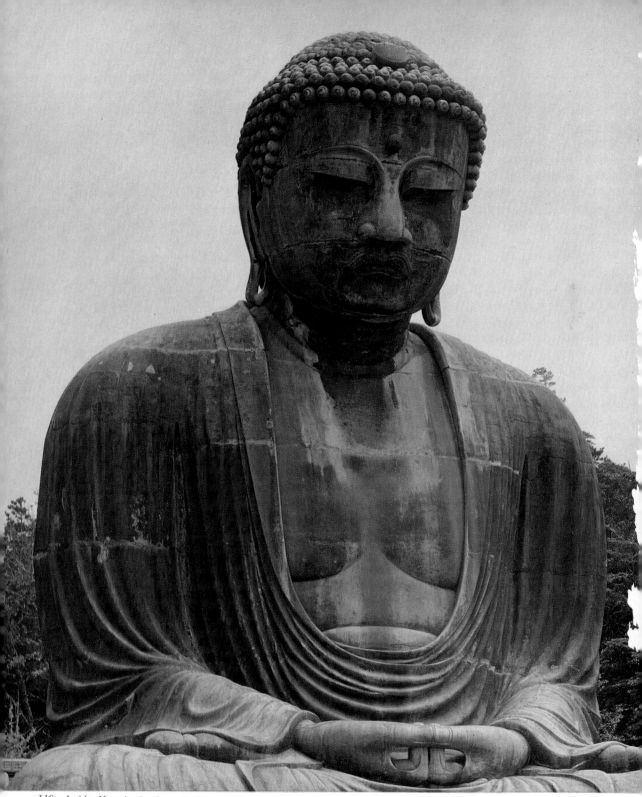

119. *Amida Nyorai, the Great Buddha of Kamakura. Bronze; height, 11.5 m. C. 1252. Kotoku-in, Kamakura, Kanagawa Prefecture.*

The Development of Medieval Popular Art: The Late Heian and Kamakura Periods

BUDDHIST PAINTING The Heian period was the golden age of Buddhist painting. As a consequence of the extensive study of iconography in connection with Esoteric Buddhism, genuine polychrome Buddhist paintings as well as line drawings in black *sumi* ink were widely produced. Masterpieces of drawing like the *Choju Jimbutsu Giga* (Scroll of Frolicking Animals and People; Fig. 124) at the Kozan-ji arose from the flourishing practice of brushwork and figure drawing.

One of the great masterpieces of polychrome painting of the time is the large *The Nirvana of the Buddha* (Fig. 88) at the Kongobu-ji on Mount Koya. It was executed in 1086, some thirty years after the Phoenix Hall of the Byodo-in was completed. The worship of Sakyamuni represented by this ancient theme had regained popularity with the revival of faith in the *Lotus Sutra*. As an illustration of the most painful of events, parting from loved ones at death, the entry into nirvana became a common theme of Buddhist painting in later times. What is noteworthy in this work is the degree to which the elegant naturalistic style of classical painting was so steadfastly preserved at the end of

the eleventh century. The use of wire-thin lines outlining the figures, as can be seen in the Horyu-ji murals, is still very much in evidence.

This great scene of lamenting disciples might almost be a Nara-period Buddhist painting. The organization of space maintains the natural perspective relationships of the classical tradition, but the coloring clearly identifies this work as a Heian Buddhist painting. Nature is amply represented in the luxuriant foliage of the Bodhi trees and the animals that join in grieving. The sensitivity of the age gives the whole painting a delicacy and refinement that was lacking in early Buddhist painting.

Another masterpiece is the painting of Sakyamuni rising from his golden coffin (Fig. 89), a work resplendent with gold and brilliant colors. This rather Christian-seeming theme is realized within the richly colored mysticism typical of Heian Buddhist painting. The dynamic postures of the characters are rendered with a powerful, rhythmic line, conveying the sense of movement of the new age. This is the determined line of the newly introduced Sung (960–1279) painting, which was immediately adopted and applied to the representation of figures to give them a sense of movement

and realism. The paintings of the goddess Kari-teimo (Fig. 115) and the god Emma Ten, ruler of the underworld, at the Daigo-ji are examples of how color is subordinated in Esoteric iconography, using the rhythmic ink line to enliven the figures.

The flourishing of art related to Pure Land Buddhism was a new element in the latter part of the Heian period. The priest Eshin (942–1017) himself had three statues of Amida in his hall and always carried out his meditations among these Buddha images. On his deathbed he is said to have followed an Indian practice and grasped a string attached to the hand of the Amida statue he had grown closest to in his daily devotions. Eshin also had a painting made of his own conception of the Amida *raigo* (Amida descending from paradise to welcome the soul of a dying believer) theme.

The Descent of Amida painting that was once in Yokawa on Mount Hiei and is today preserved on Mount Koya (Figs. 120, 121) is the most accurate representation of Eshin's magnificent conception. It depicts Amida full face, seated on a cloud, descending to earth accompanied by twenty-five bodhisattvas and heavenly musicians. A feeling of realism has been revived, movement is shown, and the figures have lively expressions. It has been suggested that the waves and wooded hills that are seen between the clouds may represent glimpses of the scenery of Lake Biwa and Mount Hiei, in the vicinity of Kyoto.

Compared with the sober, abstract style of the eleventh-century Amida image in the Hokke-ji, which with the addition of two bodhisattvas and some young acolytes in the twelfth century was made to represent the descent of Amida, this Yokawa painting is festive and musical. With the

120, 121. *Portion of* Raigo *of Amida and celestial host. Colors on silk; left-hand panel, 210.8 × 210.6 cm. Twelfth century. Yushi Hachimanko Juhakka-in, Kongobu-ji, Mount Koya, Wakayama Prefecture.*

122. *Amida beyond the Mountains. Colors on silk; 134.8 × 117.3 cm. Thirteenth century. Zenrin-ji, Kyoto.*

popularity of this theme in painting, many Amida triads were made by sculptors showing the descent of Amida.

In the thirteenth century a growing number of these Descent of Amida pictures were painted. The impression of speed gradually increased and Amida was now usually portrayed facing sideways. The painting in the Chion-in, Kyoto (Fig. 117), popularly called *Haya-raigo* (Swift Descent), shows Amida with his entourage of musicians and heavenly attendants rushing down like a whirlwind to the deathbed of the believer.

The Kamakura period saw the rise of another theme: the so-called *yamagoshi* Amida (Amida beyond the mountains; Fig. 122). Because it too shines its beneficent light on all life, the full moon rising over the edge of a richly green mountain was for the Japanese a symbol of Amida; this nature

symbolism, characteristically Japanese, is here joined to the theme of the descent of Amida. Art derived from the Amida faith is one example of the many strains of Japanese art that remained constant throughout the twelfth century and well into the Kamakura period.

PORTRAIT PAINTING At the beginning of the Kamakura period, the masters of portraiture Fujiwara Takanobu (1142–1205) and his son Nobuzane (d. 1265) felt compelled to capture the powerful, determined faces of the military heroes of the age. In the portrait of Minamoto Yoritomo at the Jingo-ji (Fig. 123), attributed to Takanobu, we recognize how strict was the discipline of the elegant tradition of the court painters.

This portrait is probably unique in Japanese painting. In Yoritomo's pale face the artist has

123. *Portrait of Minamoto Yoritomo, attributed to Fujiwara Takanobu. Colors on silk; 139.4 × 111.8 cm. Late twelfth or early thirteenth century. Jingo-ji, Kyoto.*

124 *(opposite page, top). Detail of* Choju Jimbutsu Giga *(Scroll of Frolicking Animals and People). Ink on paper; height, 31.8 cm. Mid-twelfth century. Kozan-ji, Kyoto.* ▷

125 *(opposite page, bottom). Detail of* Ban Dainagon Ekotoba *(Story of the Courtier Ban Dainagon Picture Scroll). Colors on paper; height, 31.5 cm. Second half of twelfth century. Sakai Collection, Tokyo.* ▷

grasped the subtle nuances of his mind, analyzed them, and re-created them in a living expression of his character. Geometric form has been deliberately accentuated, giving the seated figure wrapped in pitch-black robes a stern, ceremonial appearance.

Late medieval European art has also produced portrait masterpieces that combine naturalism and geometric form—for example, Fouquet's *Charles VII* and Holbein's *Henry VIII*. But this kind of intensely spiritual portrait, almost giving the impression of a deity, is not to be found in the West. The portraits of Taira Shigemori and the cloistered emperor Goshirakawa are similar examples. Unfortunately they have been badly damaged.

NARRATIVE
PICTURE SCROLLS The most distinctive new feature of the Late Heian and Kamakura periods is the development of the genre of *emaki* (narrative picture scrolls). Scroll painting was introduced from

the continent in the form of illustrated Buddhist tales, such as the Nara-period *E Inga-kyo* (Illustrated Sutra of Cause and Effect; Fig. 38) in the Ho-on-in of the Daigo-ji, Kyoto. In the early Heian period, illustrated poetry texts were also introduced, and it is clear that the Japanese *emaki* owe their origins to T'ang models. The origin of the format that we see in the early-twelfth-century *Genji Monogatari Emaki,* the alternation of pictures and text, is still unclear. The illustrations of this particular scroll may first have been painted on separate single sheets and converted to the present narrative-picture-scroll format at a later date. But by the time of the *Shigi-san Engi Emaki* (Legends of Shigi-san Temple Picture Scroll), *Kibi Daijin Nitto Emaki* (Minister Kibi's Trip to China Picture Scroll), and *Ban Dainagon Ekotoba* (Story of the Courtier Ban Dainagon Picture Scroll) of the latter half of the twelfth century, the format is already established, and a competitive interplay between

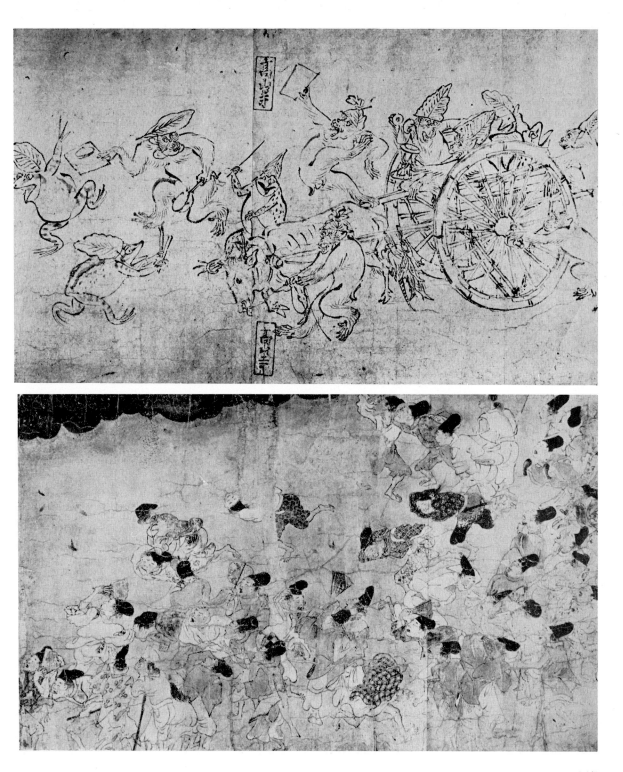

126. *Detail of catchball scene decorating a chest. Colors on wood. Second half of ninth century. To-ji, Kyoto.*

narrative and illustrations has begun. (In medieval Europe, too, illustration and decoration of manuscript copies of the Bible and other works were known from an early date. The sources of this custom are found in the illustrated scrolls of literary works, medical texts, and even the Old Testament at Alexandria. When bound books replaced scrolls, the custom of illustration was simply carried over to the new format.)

The most noted Kamakura-period *emaki* are legends of the founding of Buddhist temples and Shinto shrines and stories of the lives of Buddhist saints. It is amazing how many temples, shrines, and religious and secular groups attempted to justify their existence on the basis of historical evidence. One is reminded how in Europe in the thirteenth century many guilds donated simple stained-glass illustrations of the lives of their patron

saints to Chartres Cathedral and how Giotto made more than forty great paintings illustrating the life of Saint Francis for the church of Assisi, thus beginning the fourteenth-century Italian fashion for pictures illustrating the lives of the saints.

In the case of Japan, this reawakening of historical awareness is probably due largely to the decline of the court aristocracy and rise of the warrior class and other social groups at the time of the transition from the Heian to the Kamakura period. The change may be traced from the panel pictures behind the principal image of the Phoenix Hall. Gradually, the lively forms of common people in action became a theme of narrative art. The individual pictures of both the *Shigi-san Engi* and *Ban Dainagon* scrolls are dynamically conceived compositions. In the *Ban Dainagon* scroll, powerful coloring forms an effective background for the

127, 128. Two bearded men; sketches on ceiling of Kondo. Ink on wood. Late seventh or early eighth century. Horyu-ji, Nara Prefecture.

129. Figures sketched on door of Phoenix Hall. Ink on wood. 1053. Byodo-in, Uji, Kyoto Prefecture.

lively delineation of the consternation and confused movements as the crowd rushes to see a burning gate (Fig. 125). A feeling of realism has finally been achieved.

The artist of the *Shigi-san Engi* scroll (Fig. 91) sets an entire scene with light colors, painting in the figures and scenery with the superbly skilled brushwork that is his forte. The sense of action is so convincing that one can almost hear people's voices. From the way the principal character of a scene always dominates it we sense the artist's presence as psychologist and moralist. A mature and mellowed humor is also evident. The *Ban Dainagon* scroll shows the influence of training in the court's Office of Painting (Edokoro), while in the *Shigi-san Engi* scroll we find echoes of the temple environment that produced the twelfth-century *Choju Jimbutsu Giga* at the Kozan-ji, Kyoto. Both

these scrolls, as also the contemporary *Kibi Daijin Nitto Emaki*, were painted by artists with distinctly personal styles. We recognize from the brushwork and figure drawing, however, that they were also men of similar background and training.

The T'ang style of painting, transplanted from China to Japan during the Nara period, sparked the creation of a simple sketching style that anyone could understand and practice, as can be seen from the ink-on-hemp monochrome painting in the Shoso-in, the sketch of a ball game on a chest in the To-ji (Fig. 126), the sketches in the Horyu-ji *kondo* (Figs. 127, 128), and those in the Phoenix Hall of the Byodo-in (Fig. 129). In the case of large paintings, in contrast with the classical style, the new style that arose in the Heian period stressed color and plane rather than line. This did not, however, cause the disappearance of the classical

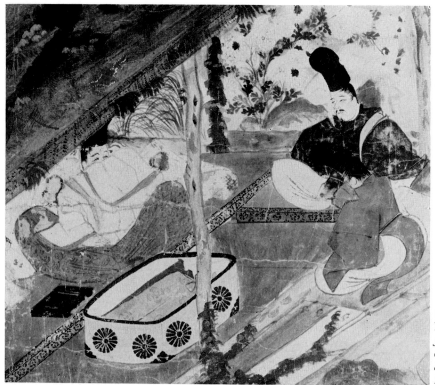

130. *Detail of* Kitano Tenjin Engi *(Legends of Kitano Tenjin Shrine) picture scroll. Colors on paper; height, 51.5 cm. Second half of thirteenth century. Kitano Temman-gu, Kyoto.*

tradition after the Nara period. Just as Kamakura-period sculpture revived the style of the Tempyo period, Kamakura painting returned to the classical tradition. But now it was not an expression of emotion that was sought in painting but an image of man characterized by will and action.

Most of the major characteristics of both the style and content of the picture scrolls of the Kamakura period were established by the end of the Heian period. However, among the many extant works, some large scrolls, such as the *Kitano Tenjin Engi* (Legends of Kitano Tenjin Shrine; Fig. 130) picture scroll of the second half of the thirteenth century, depart from the character of narrative illustration to such an extent that they may be regarded as paintings aside from their narrative content. They do not merely record incidents but build out of various elements a picture that can stand independent of its story content. Full consideration is given to harmony and contrast of color and form. More important is the new quality of sensitivity in the painting; there is a striving to represent the actual moods of nature and feelings of human beings. This is a characteristic shared by numerous scrolls. The vision of artists had widened, and on occasion, they allowed their curiosity full reign.

The immense *Ippen Hijiri Emaki* (Biography of Saint Ippen Picture Scroll; Fig. 131) in the Kankiko-ji, Kyoto, was painted in 1299. Scenes of Ippen, the itinerant monk who founded the Jishu Buddhist sect, preaching throughout the country and landscapes, street scenes, and crowds are depicted in great detail and worked into an impressive composition. One wonders if the artist perhaps received some inspiration from Sung painting.

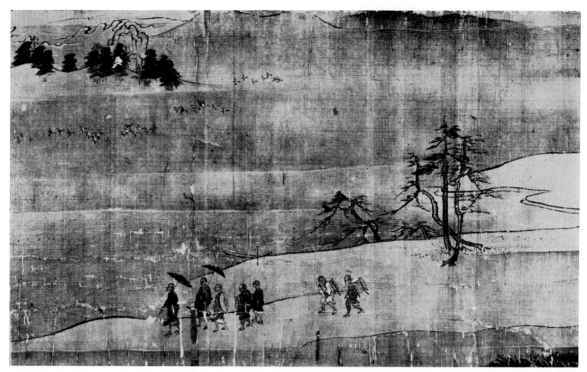

131. *Detail of* Ippen Hijiri Emaki *(Biography of Saint Ippen Picture Scroll), by En'i. Colors on silk; height, 38.2 cm. 1299. Kankiko-ji, Kyoto.*

Each scene reflects the artist's experience of a life closely bound to the land and the people. Like the Flemish religious paintings of the fifteenth century, each picture is colored with the pigments of the artist's own life.

The *Ippen Hijiri* scroll differs from narrative scrolls like *Ban Dainagon* and *Shigi-san Engi*. The painter was probably a priest, who put his whole being into recording the deeds of the monk. The paintings are presented as evidence to reaffirm Ippen's deeds. This record is a kind of portrait of Ippen.

In the picture scrolls, we can easily see elements heralding the *chinzo* portraits of Zen monks, such as that of Daikaku Zenji in the Kencho-ji or that of Daito Kokushi in the Daitoku-ji, Kyoto. The artists here evidence a strong interest in human beings, particularly in spiritual personalities rather

than warriors or politicians. This interest led to the creation of sculpture and paintings of men of religion, to be placed in temples alongside the buddhas and bodhisattvas.

A strange new genre of paintings of ugly, horrifying subjects came into vogue at the beginning of the Kamakura period. The *Jigoku Zoshi* (Scroll of Hell; Fig. 132) and the *Yamai Zoshi* (Scroll of Diseases and Deformities), both painted in the late twelfth century, are typical examples. There were many evil demons in the Heian capital, but they seem only rarely to have found their way into paintings. Occasionally there was a representation of a person possessed by a jealous or malicious spirit. The god of lightning in the *Kitano Tenjin Engi* scroll may have a Heian-period prototype. But in an age of action, malignant spirits flee. Instead, man himself appears fearful and abominable.

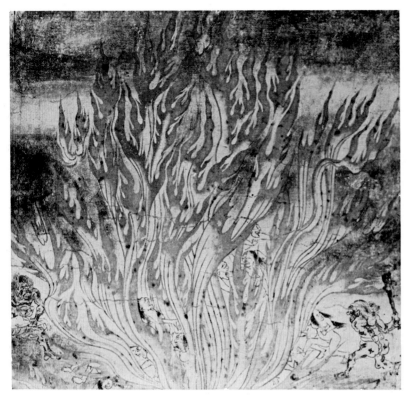

132. *Detail of* Jigoku Zoshi *(Scroll of Hell). Colors on paper; height, 26.1 cm. Late twelfth century. Tokyo National Museum.*

Judgment and punishment, illness, filth, deformity, and corruption—tangible terror is shown in many exaggerated forms in these scrolls. The grotesque vision of hell is depicted with anguished realism. Priest Eshin's *Ojo Yoshu,* a treatise on rebirth in the Pure Land, was probably the source of this new attitude in religion and its manifestation in art. The age that sought the paradise of the Pure Land was compelled to create also an image of its opposite, a horrible hell, as an aid to deepening man's knowledge and religious devotion. Emma, king of the underworld, and the demons of hell become busy. The compassionate bodhisattvas Kannon and Jizo lend their ears to people's prayers. In such an age it is only natural that both the buddhas and the demons of hell should appear among human figures. No other period of Japanese art showed man in so many different forms.

KAMAKURA ARCHITECTURE

The first major architectural undertaking after the establishment of the new military government of Minamoto Yoritomo in Kamakura in 1185 was the reconstruction of the Todai-ji and Kofuku-ji temples in Nara, burned in 1180 in the Minamoto-Taira civil war. The priest Chogen, having undertaken the reconstruction of the Todai-ji, collected donations throughout the country and with the aid of the *bakufu* (military government) rebuilt the Great Buddha Hall, completing it in 1195 (it was destroyed by fire again in 1567 and rebuilt in 1708). Chogen also rebuilt the Nandai-mon gate of the Todai-ji in 1199 (Fig. 133). The method of construction used was the so-called *daibutsu-yo* (Great Buddha style, also called *tenjiko-yo,* or Indian style), developed by Chogen on the basis of Sung Chinese construction techniques.

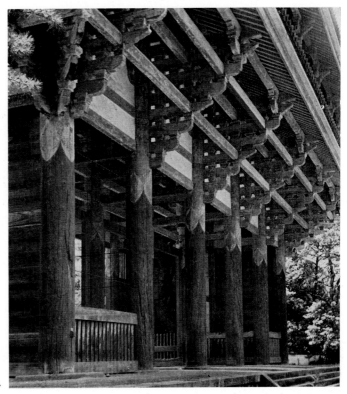

133. Nandaimon. 1199. Todai-ji, Nara.

The main buildings of the Kofuku-ji, such as the eastern and central *kondo*, were also rebuilt by the end of the twelfth century (the northern *endo*, or circular hall, in Figure 134 and the pagoda still stand). Unlike the Todai-ji, the Kofuku-ji reconstruction was carried out in the original *wa-yo* style dating from the Nara period. When we reflect that the reevaluation of Nara styles was the trend of the times not only in sculpture but also in painting, the skillful application of the *wa-yo* style at Kofuku-ji assumes a special significance. However, even though this style has been retained, if we compare the northern *endo* (begun in 1210) with the Yumedono of the Horyu-ji we find certain differences. The bracketing has been doubled, making the Kofuku-ji structure taller, and the slope of the roof is steeper. The interior follows the plan of a two-story octagonal *endo*. The ceiling, consisting of

two stages—a central section and a peripheral one —approaches the dome form. As compared with the original Nara temples, the soaring effect of temple buildings created by making the roof slope steeper is undoubtedly a characteristic of Kamakura temple architecture.

The classical harmony of Nara-period *wa-yo* architecture—achieved by using cylindrical pillars as idealized forms of the human body and by taking pains not to destroy the harmony of human proportions in the combination of pillars, bracketing, and beams—has been overwhelmed by the conception and structure of the whole building. It is not that the construction has taken precedence over the design. The construction itself becomes the design, a design different from the harmony of human proportions.

The architectural style that accompanied the

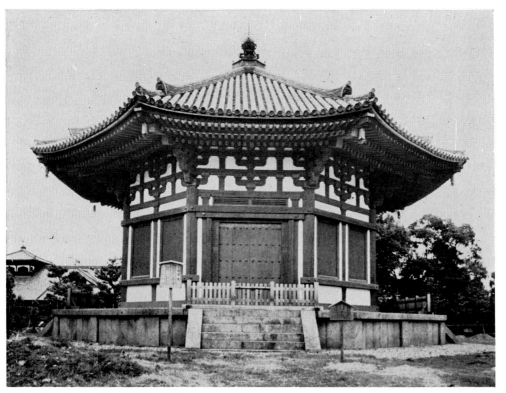

134. North Endo. 1210. Kofuku-ji, Nara.

introduction to Japan of the Zen sect of Buddhism, and spread with that sect, lacks the crudeness that emerged from the mixture of structural and decorative elements in the *daibutsu-yo* style. The refined technique of this architecture, its skillful use of materials, and the new curved forms of window and door frames remind one of certain details of Indian and Islamic architecture. The stimulus that this Sung style gave Japanese Buddhist architecture from the mid-Kamakura period onward was considerable.

The Zen-style *butsuden* (buddha hall) is one of the most perfect examples of forms of architecture that reconstruct in wood the equivalent of the two-story structure consisting of a dome placed over a square area. It is natural therefore that various Central Asian ornamental themes should have accompanied this style. The elaborate bracketing that fills the space under the eaves is no longer linked to the columns. It has combined with the wall surface under the eaves that surround the whole building and has become a structural ornament, used with masterly skill to bridge the transition from the vertical walls to the steeply sloping curved roof. The interior is a high space narrowing toward the top. The double-layer effect of the transition from the lower row of brackets to the bracketing on the arched beams above (Fig. 135) is fascinating. Anyone who is familiar with the interiors of domed buildings will immediately realize that this is a wooden version of the dome.

KAMAKURA SCULPTURE The paintings of the Buddhist saints Honen and Shinran, the wooden sculpture of Kuya, Unkei's sculptures of Mujaku and Seshin, Kaikei's Ten

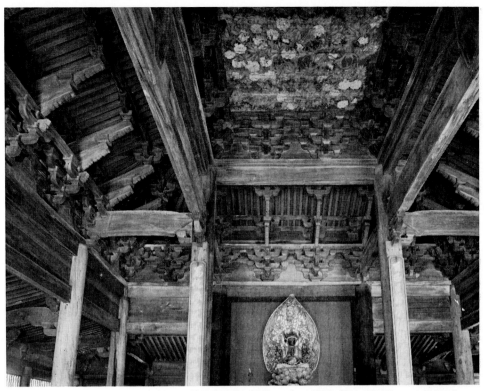

135. Interior of Butsuden. 1320. Kozan-ji, Yamaguchi Prefecture.

Great Disciples, and the sculptures of the bodhisatt-va Jizo make us realize just how close the world of buddhas and bodhisattvas was to the people of the Kamakura period. We can understand how it was that sculpture played such an important role in symbolizing the spirit of the age. Kamakura art is represented by sculpture; and the man who created Kamakura sculpture was Unkei.

At the Nandaimon gate of the rebuilt Todai-ji stand two gigantic guardian kings, or Ni-o (made in 1203; Fig. 136). These immense wooden sculptures were carved by the genius Unkei (d. 1223) and his contemporary, the brilliant Kaikei, although it is difficult to say who carved which statue. Although the two sculptors normally produced work of very different character, the result of this collaboration is a harmonious unity. One feels the energy that enabled them, with the help of their pupils, to

produce these eight-meter-tall sculptures in some two and a half months.

This was not their first experience with large wooden sculptures. In 1196, together with Kokei (Unkei's father) and Jokaku, they had carved six large statues for the Great Buddha Hall of the Todai-ji—two bodhisattva attendants and the Four Celestial Guardians. Unkei and Kaikei made one guardian each. The late Jun Kanamori, a renowned scholar of Japanese sculpture, has pointed out that these huge works were made by a joined-wood tech-nique developed at the end of the Heian period; eighty sculptors and numerous other craftsmen shared the work under the supervision of the four master sculptors. A master sculptor was responsible for each statue. He made the left and right halves separately, after which the two were joined.

Kamakura sculptures of deities suit the vigor of

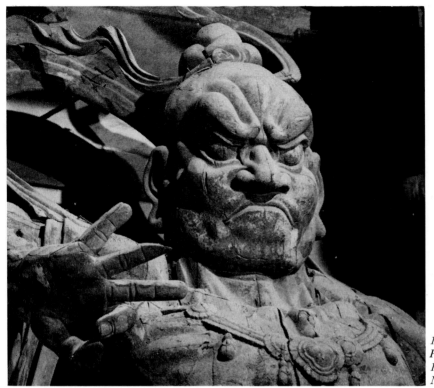

136. Ni-o, by Unkei and Kaikei. Painted wood; height, 848 cm. 1203. Nandaimon, Todai-ji, Nara.

this period perfectly. The images of the Four Celestial Guardians are said to have been made with the support of the military government and its vassals, and these as well as the two guardian kings reflect the temperament of the Kamakura warrior. Efforts to convey the character of such Tempyo-period clay statues as the Four Celestial Guardians in the Kaidan-in at the Todai-ji (Figs. 69, 70) were concentrated on facial expression, and only faintly suggested in the posture of the body. In the Kamakura statues, however, the sense of bodily movement is crucial and the huge masses of wood of which the bodies are made were used most effectively to convey this. Terrific tension is also concentrated in the face. These fearsome statues are powerful symbols of the will and action of the period.

Kamakura sculpture does not neglect the body but clearly indicates its configuration under the drapery. Indeed, the Ni-o (Fig. 137) by Jokei, Unkei's second son, reveals in the depiction of musculature, bone structure, and blood vessels the sculptor's interest in anatomy. The statue is a fine sculpture, but in this analytical realism a single misstep could have led to a cold academicism. Koben's (Unkei's third son) statues of the lantern-bearing demons Ryutoki (Fig. 138) and Tentoki (Fig. 139) demonstrate that the sculptor had a thorough knowledge of the human body and was sensitive to its inner structure as well as its external form. There is also a certain humor in the straining of the powerful muscles. Something about these figures that seems very close to Hellenistic sculpture makes us almost wonder whether the sculptor had seen the ancient Greek statue of a satyr bearing a lantern, now in Naples.

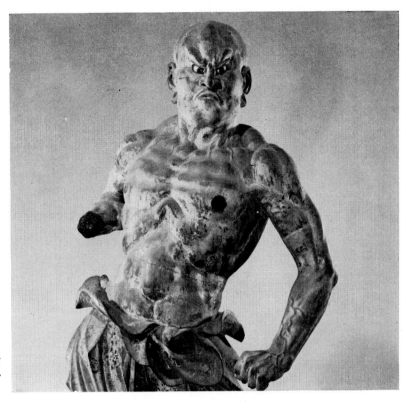

137. *Ni-o, by Jokei. Painted wood;
height, 161.5 cm. Thirteenth century.
Kofuku-ji, Nara.*

There is a tendency in Kamakura sculpture, encouraged by emotionalism, to destroy classical harmony and move on to a baroque form of expression. Of course, the object was not simply representation of the human body. The sculptor's aim was to depict man himself, man as people see him, as they live with him in everyday life. By expressing what is in his heart, by using man's form, the artist strives to represent the buddhas, bodhisattvas, disciples, and even hell's demons as familiar beings. Unkei, Kaikei, and their contemporaries and successors all worked from such naturalistic premises.

In the mid-eleventh century, when Jocho was making the joined-wood principal image of the Phoenix Hall, he yielded to the opulent decorative tendency of the art of that time and suppressed the expressiveness of his statue, seeking to harmonize it with the decorative elements of the mandorla, canopy, and base. Kamakura sculpture shows no such reticence. Any number of statues were produced that do not call for the aid of the decorative arts or architecture; they are complete in themselves. Not even the sculpture of the golden age of Tempyo asserted its independent existence as strongly as this.

As the art historian Hisashi Mori has pointed out, Unkei's late masterpieces of the Indian Buddhist laymen Mujaku (Asanga; Fig. 143) and Seshin (Vasubandhu) are noted for their sense of mass. They have a weightiness about them that makes one think they have taken root. One feels that here finally is true sculpture. Unkei revived in his statues the authority of sculpture. Having grown up in Nara, with the masterpieces of the Tempyo period always vivid and close at hand, he was in-

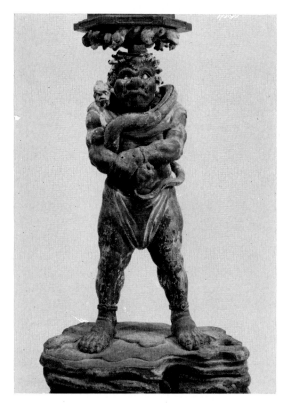

138. *Ryutoki, by Koben. Painted wood; height, 77.5 cm. 1215. Kofuku-ji, Nara.*

vited by the priest Mongaku to help with repair work on the To-ji and Jingo-ji from 1197 to 1203. He thus had the opportunity of studying firsthand some of the masterpieces of the Jogan era. In his later years (after 1208), he worked on the north *endo* of the Kofuku-ji. His statues of Miroku, Mujaku, and Seshin, extant today, demonstrate his genius in capturing in sculpture the human spirit. In this respect, Unkei far surpasses all other sculptors of the period.

The seated figure of Dainichi Nyorai in the Enjoji, Nara (Fig. 142), signed by Unkei and Kokei, has a neat, clean-cut beauty. Made between 1175 and 1176, it is Unkei's earliest known work. In its present condition, with most of the gold leaf peeled away, the lustrous, dark purple lacquer ground lends a tautness to the simple shape of the figure.

The sculpture of the last part of the Heian period

reflects the unsettled history of the times. As mentioned above, the central feature of the period was the stressing of mass and movement. Unkei's father, Kokei, is representative of this tendency. The figures of the Fukukenjaku Kannon, the Four Celestial Guardians, and the Six Patriarchs of the Hosso Sect (Figs. 140, 141) made by Kokei in the last years of his life for the south *endo* of the Kofuku-ji already indicate the direction that the sculpture of his disciples and his son Unkei would take. Kokei's buddhas and deities still show the heavy-handed ornamentalism and sensuousness of Fujiwara sculpture, with some tendency to sink into formalism. Nevertheless, they have a new, purposeful sense of motion, and show the fruits of a century of efforts made by the sculptors of Nara in studying the Tempyo works of sculpture.

In his statues of the patriarchs Kokei followed

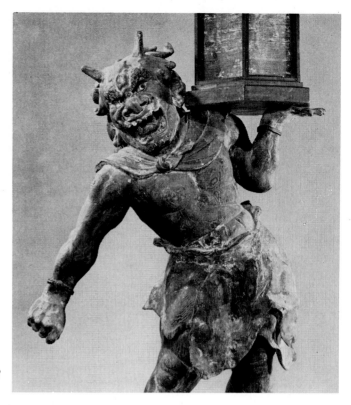

139. Tentoki, by Koben. Painted wood; height, 77.8 cm. 1215. Kofuku-ji, Nara.

the example of the Tempyo style but added his own observation of human nature in such details as the wrinkles on the faces. He attempted to express his own perception of the personalities of high-ranking monks. But some old formulas he was never able to escape, as we realize when we compare his work with his son Unkei's statues of Mujaku, Seshin, the celestial guardians, and Miroku. Only about twenty years separate Unkei's Mujaku and Seshin from Kokei's six patriarchs, but we can see how great were the changes that had taken place during these two decades. The contrast between the works of father and son is as striking as that separating the Romanesque and Gothic styles of late-thirteenth-century European sculpture.

The Dainichi Nyorai at the Enjo-ji is already tense with the youthful purity typical of Unkei's work. His faith was complete, and he was able to put his whole heart into making this impressive figure meditating on the ultimate essence of the universe. Consequently there is no going astray into sensuousness, no playing with technique.

Hisashi Mori has pointed out that to understand Unkei's work, it is important to remember that he had the *Lotus Sutra* copied in eight scrolls, and that he went to Kamakura, where he came into contact with the rigorous, down-to-earth military society of the new capital. Having absorbed the atmosphere of the samurai, who were the moving force behind the age, he became more broad-minded. He must have been very pleased, therefore, when the opportunity came to make the giant statues of the Great Buddha Hall and the guardian kings of the Nandaimon gate, for these were projects that matched his own scale as a sculptor.

But the work that expresses Unkei's spirit best of

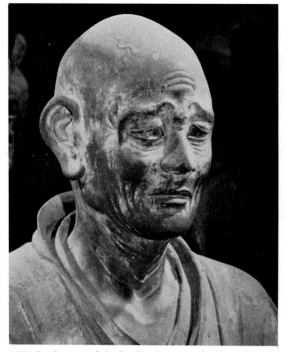

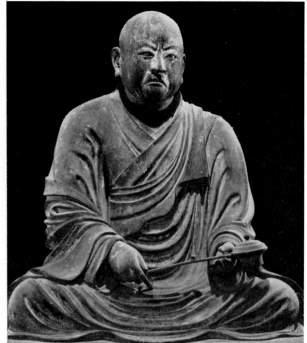

140. Gembo, one of the Six Patriarchs of the Hosso Sect, by Kokei. Painted wood; height, 86 cm. 1189. Kofuku-ji, Nara.

141. Zenju, one of the Six Patriarchs of the Hosso Sect, by Kokei. Painted wood; height, 84.3 cm. 1189. Kofuku-ji, Nara.

all is the seated figure of the bodhisattva Jizo at the Rokuharamitsu-ji in Kyoto (Fig. 145). By the time Unkei made this he had already mastered the techniques of the Jogan-era Esoteric sculpture that he had studied at the To-ji and Jingo-ji. There can be few works that teach us the secrets of Esoteric Buddhism in so direct a form. The sound classicism of the Tempyo period has been revived here through the vigorous emotions of everyday life in Unkei's time. In this image of the bodhisattva who is prepared to descend to hell himself in order to save mankind, Unkei has created the work most perfectly representative of Kamakura sculpture.

Despite some admixture of Sung influences, Unkei's tradition was continued basically unchanged by the sculptors of Kamakura. The symbol of the age, the Great Buddha at the Kotoku-in in Kamakura (Fig. 119), suggests the style of the Unkei

school of sculptors. The situation of his sons and pupils in Nara was more complicated. The works of Tankei, Koben, and Koshun, who inherited Unkei's style but combined it with Sung elements, are quite similar to the works of the sculptors in Kamakura. As one might expect in so rich a cultural environment, they show exceptional refinement and technical elaboration. Nara sculptors had as a model the virile style of Kokei, which had resulted from adding revived Tempyo characteristics to the legacy of Fujiwara sculpture beginning with Jocho. But they all studied assiduously, like Jocho, and many a sculptor seems to have considered his own style a school in itself. This striving for self-expression is analogous to the manner in which the various sects of Kamakura Buddhism vied with each other in social activism in order to gain adherents.

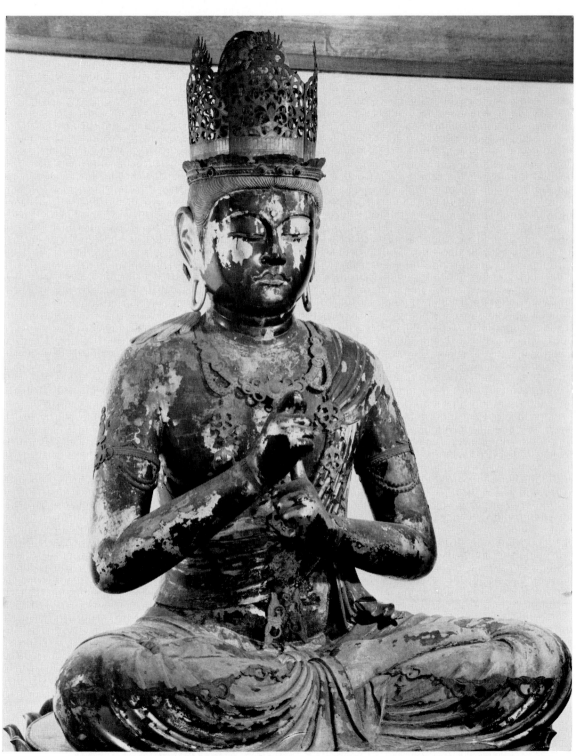

142. Dainichi Nyorai, by Unkei. Gilt lacquer on wood; height, 101 cm. 1176. Enjo-ji, Nara.

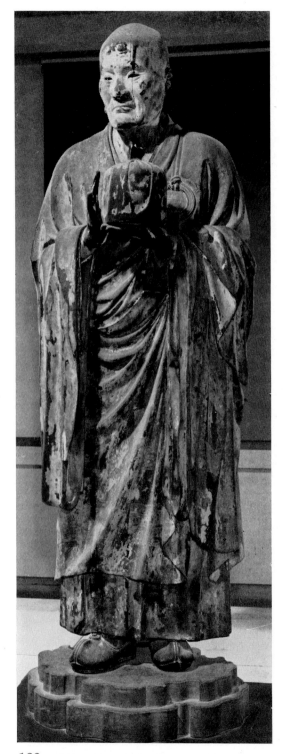

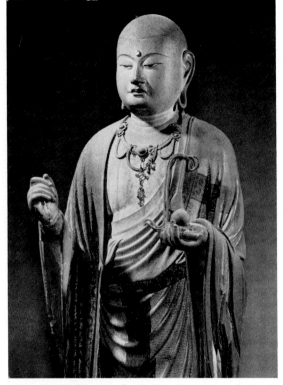

144. *Jizo Bodhisattva, by Kaikei. Painted wood; height, 90.6 cm. Early thirteenth century. Todai-ji, Nara.*

143. *Mujaku, by Unkei. Painted wood; height, 194 cm. 1208. North Endo, Kofuku-ji, Nara.*

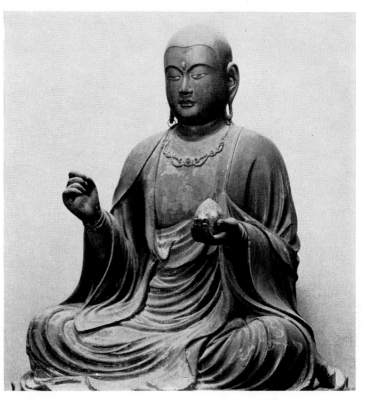

145. *Jizo Bodhisattva, by Unkei. Painted wood; height, 89.5 cm. Late twelfth century. Rokuharamitsu-ji, Kyoto.*

If we seek similar examples in the history of European medieval art, what comes first to mind is the period in fourteenth-century Italian painting when Giotto and his pupils, Duccio, Simone Martini, and the Lorenzetti brothers were active, rather than thirteenth-century Gothic sculpture. One man among the sculptors in Nara prompts this comparison with the art of the Siena school, an art that strove to develop a beautiful style of elaborate technique to express medieval religious feeling. That is the supremely creative sculptor Kaikei.

Kaikei was Unkei's collaborator and rival. He tried his hand at many different styles—Kokei's style, the straightforward realism of Unkei and his group, and the new realism of the Sung style. At the beginning of the thirteenth century he perfected his own unique Annami style—an elegant, refined

style that is immediately recognizable (Fig. 144). With this he fixed the style of subsequent buddha and bodhisattva images in Japan. Both his pupils and later the sculptors of the Muromachi period respectfully adopted the Annami style. In it Buddhist sculpture approaches Buddhist painting in feeling, with color, line, and mass harmoniously amalgamated in brilliant creations. But in his last years, Kaikei himself returned to the extremely natural faith symbolized by the Amida Nyorai in the Saiho-in, Nara, and the Ten Great Disciples in the Daiho-on-ji, Kyoto (Fig. 146).

The creative period of Japanese sculpture, which had occupied such a proud position in the history of world sculpture, finally came to an end during the early Kamakura period. Buddhist sculpture continued to be produced through the Muromachi

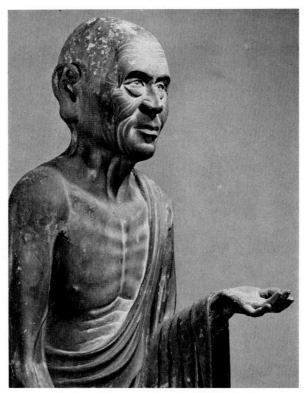

146. Mokukenren (Maudgalyayana), one of the Ten Great Disciples, by Kaikei. Painted wood; height, 96.7 cm. Thirteenth century. Daiho-on-ji, Kyoto.

and Edo periods, but the main forms had been established in Kamakura times.

During the Momoyama period (1568–1603) wood carving came to play a completely different role. Elaborate, brightly colored carvings were used as architectural ornaments on shrines and mausoleums. Flowers and birds, human figures, and all kinds of patterns were to be found in every conceivable place—room partitions, ceilings, bargeboards. But the art of sculpture as a vehicle of philosophical or religious concepts ended with the Kamakura period. And until the introduction of Western sculpture in the Meiji era (1868–1912), the role this art had played was absorbed by such Japanese theatrical arts as Noh, the puppet drama, and Kabuki. The unique character of these Japa-

nese dramatic forms is due to a skillful use of sculptural effects. The performer's body itself takes on sculptured form, and gestures, movements, and expressions are executed according to the principles of plastic art. A sculptural world is realized on the stage.

There are times when good sculpture seems to have more reality than the people looking at it. When the formalism of the Japanese people is supported by a warm feeling for life, it makes possible a kind of purification of the inconsistencies of reality. Thus even though the creative activity of Buddhist sculpture had ceased, its formative spirit continued through later centuries to function in such arts as flower arrangement and the tea ceremony.

Suibokuga and Decorative Painting: The Muromachi, Momoyama, and Edo Periods

THE WORLD OF SUIBOKUGA The arrival of monochrome ink painting, or *suibokuga*, on the artistic scene during the Muromachi period marked a crucial turning point in the history of Japanese art. It is not simply a question of the sudden influence of Sung and Yuan (1270–1368) painting, for the effects of Sung styles can be detected in Late Heian Buddhist painting and in the Kamakura-period picture scrolls and portraits. Sung painting had served to reinforce and invigorate classical traditions in Japan. Painting exclusively in black ink, however, set in motion an entirely new current in Japanese art, different from both the classical and the *yamato-e* traditions.

Japanese ink painting appeared first in Zen circles in the Kamakura period with simple drawings on paper of a personage from a Zen story or a few flowers. Later, landscapes were depicted, and, with the addition of a poem, a kind of painting known as *shigajiku* (literally, "poem-and-picture hanging scroll") was produced. These were usually executed by monks attempting to represent their inner microcosm in visual form.

Suibokuga landscapes were not copied from nature. In the manner of Southern Sung (1127–1279) artists, especially the great thirteenth-century painters Ma Yuan and Hsia Kuei, they set on paper their own inner conception of nature. For the representation of mountains, rocks, cliffs, trees, rivers, clouds, haze, and even the composition of the landcape—in other words, the vocabulary and syntax of their art—the Japanese painters borrowed the creative language of Ma Yuan and Hsia Kuei, using it to express their own poetic sentiments. These landscapes, composed of strong shapes but eliminating color, were the ideal expression of the Zen monks' abstract aim of transcending the colors of trees and flowers and attaining a sympathetic union with nature in its eternal aspects. The flat, horizontal spatial organization of earlier Buddhist painting and the folding-screen and picture-scroll genres were inadequate to reveal the inward vision of the thinking and feeling self. In *suibokuga*, to suggest boundless space, rocks, water, and trees were placed in the foreground and mountains added in the distance. Among these were spread ink washes of varying size and density of tone.

Such expressive tendencies were not confined to the fine arts. As early as the Kamakura period, Japanese poets were attracted by the profound

truths hidden in nature rather than its external manifestations. In literature the *renga* verse form of linked short poems expresses this sensitivity to the abstract.

As part of their education in Sung and Yuan culture, the Zen monks of the Muromachi period once again studied Chinese landscape painting. Sung landscape painting had developed on the basis of the Chinese cosmological tradition, and had as its spiritual background the exploration of the self emphasized in Sung philosophy. It set out to transform the passion for physical objects of classical T'ang painters by stressing the individual painter's personal vision.

The unique "poetic" perspective of Far Eastern landscape painting lacks the fixed, clear, geometrical spatial structure of the linear perspective developed in Renaissance Europe. Instead, Eastern art evolved a vague, flexible perspective allowing freedom of life and of the spirit. Yet the two traditions share a rejection of the flat structure of the great medieval paintings and seek instead an image of the cosmos within the artist's heart to project into painting. The element of incompleteness inherent in art as a projection of consciousness of the self, that is, of the continuity of consciousness, is easily expressed in Eastern landscape painting, since a system like scientific perspective that functions to fix a series of images is weak. It is rather the presentation of a space that is the ultimate object of landscape painting in the East. This space is an integral part of the composition, an emptiness that "lives." Sesshu's *Haboku Landscape* (Splashed-ink Landscape; Fig. 149) and the landscapes of Shubun (Figs. 150, 154) and the Southern Sung painters Mu-ch'i and Yu-chien (Figs. 147, 148, respectively) are supreme examples of this art of "living" space.

Shubun's successors, and probably Shubun himself, painted large monochrome landscapes and pictures of flowers and birds on screens and *fusuma* (paper-covered sliding doors) in Zen temples, thus initiating a new mode of room decoration in the mid-fifteenth century. At the same time, the Japanese feeling for nature is expressed in the *suibokuga* hills and valleys covered by soft, hazy rain and

147. Sunset over a Fishing Village, *from* Eight Views of the Hsiao and the Hsiang, *attributed to Mu-ch'i. Ink on paper; 33× 113 cm. Twelfth or thirteenth century. Nezu Art Museum.*

148. Mountain Landscape, *from* Eight Views of the Hsiao and the Hsiang, *by Yu-chien. Ink on paper; 33× 84 cm. Twelfth or thirteenth century. Yoshikawa Collection, Tokyo.*

149. Haboku Landscape, *by Sesshu. Ink on paper;* 147.8×32.7 cm. 1495. Tokyo National Museum.

150. Mountain Landscape, *attributed to Shubun. Ink on paper; 108.2×32.7 cm. First half of fifteenth century. Fujiwara Collection, Tokyo.*

trees, or riverside thickets, or flowers and birds. Among them, works like the *fusuma* landscape attributed to Soga Jasoku in the Shinju-an of the Daitoku-ji (Fig. 157) are outstanding for their profound spirit and keen perception of nature.

SESSHU'S ART It was Sesshu (c. 1420–1506) who, following in the footsteps of Shubun and other predecessors, brought Japanese ink painting to perfection. Unlike the earlier artist Soami, he does not restrict the expressive possibilities of ink painting to traditional Japanese landscapes. By use of a powerful line and modulations of tone, Sesshu gives his mountains, rocks, trees, banks, and rivers a three-dimensional look (Fig. 156). Vigorous forms are firmly placed in the picture, and their relative positions define the

perspective relationships of the picture space. Vertical lines suggest the relative positions of the forms and imply depth. Horizontals establish stability and breadth. Transitions and connections in the perspective relationships are indicated by diagonal lines. The line sets off the empty portions of the paper that constitute the highlights and, together with the wash shading, produces the forms.

Sesshu's art has taken a step beyond the Zen environment of contemplation and displays will and initiative, as if the artist were directing the formation of the new art of the modern society to come. In his black and white forms, renouncing both emotionalism and sensualism and even the material quality of objects, he stresses strong, purposeful composition. Moreover, his completeness of form and composition are born not of

151. *Portrait of Masuda Kanetaka, by Sesshu. Colors on paper; 82.1×40.3 cm. 1479. Masuda Collection, Tokyo.*

together and "discussing life" enables him to combine the atmospheric effects of Chinese painting with the narrative tradition of the Japanese *emaki*. Sesshu, in complete command of *suibokuga* techniques, uses his brush to depict both man and nature in his paintings.

Subscribing to the tradition of idealized landscape in the Chinese manner, Sesshu rarely painted the scenery of specific locations. However, late in life he was greatly moved by Ama no Hashidate and its surrounding mountains, a famous scenic spot on the Japan Sea coast in present-day Kyoto Prefecture. In the masterpiece he produced, the brush applied to the paper again and again seems to set an echo resounding throughout the painting. The abbreviated suggestion of landscape in the *Haboku Landscape* is an improvised projection of his creative consciousness.

A tremendously active painter, Sesshu also must have done large landscapes and bird-and-flower paintings in the *fusuma* and screen formats. His work provided the foundation of ink-painting style for large-scale paintings, and his influence on the painting of the next period was enormous.

contemplation but of the experiences of activity.

Consider *Hui K'o Offering His Severed Arm to Bodhidharma* (*Eka Dampi;* Fig. 155). The frank, straightforward figure of Sesshu himself stands in the entrance to the cave, solemn and determined. In his portrait of Masuda Kanetaka (Fig. 151), with a reticent line reminiscent of *yamato-e* portraits, Sesshu endows the figure with the solidity of a rock. Sesshu traveled widely in both Japan and China, and paintings like *Chinda no Taki* (The Chinda Waterfall) and *Ama no Hashidate* (Fig. 152) communicate his emotional response to these spots. The *Sansui Chokan* (Long Landscape Scroll; Fig. 153) reveals his inventiveness and ingenuity in working within the spatial limitations of the scroll form. At the same time, the inclusion throughout this long Sung-style scroll of two figures traveling

THE KANO SCHOOL Together with Shubun, Sotan, Jasoku, and Sesshu, two other artists are considered representative of the *kanga,* or Chinese-painting, style in the Muromachi period—Kano Masanobu (1434–1530) and his son Motonobu (1476–1559). Masanobu, official painter at the academy of the Muromachi government, was of samurai origin and therefore had a rather different outlook from the Zen monks. Shubun had let his poetic feeling roam through the depths of abstract space, whereas Sesshu not only structured space for the logical development of thought through the conscious accumulation of powerful forms but also regarded his work as a manifestation of his vision of volitional acts. In contrast, Masanobu and Motonobu used *suibokuga* techniques to re-create their vision of actual life. They brought back the sensuous, which Sesshu had deliberately excluded, and they connected fact and reality with art. This became the basic policy of their successors in the Kano tradition.

152. Detail of Ama no Hashidate, *by Sesshu. Ink on paper; 89.4 × 168.8 cm. Early sixteenth century. Kyoto National Museum.*

153. Landscape of the Four Seasons, *from Sansui Chokan,* by Sesshu. Colors on paper; overall dimensions, 40 × 1,807 cm. *1486. Mori Collection, Yamaguchi Prefecture.*

154. Detail of Scholar's Retreat in a Bamboo Grove, *attributed to Shubun. Ink on paper; overall dimensions, 134.8 × 33.3 cm.* ▷
C. 1450. Tokyo National Museum.

面水好山皆可廬
唯多竹更称吾廬
應言門非是嚴佳宅
日課猶愁欠讀書
村巷靈産

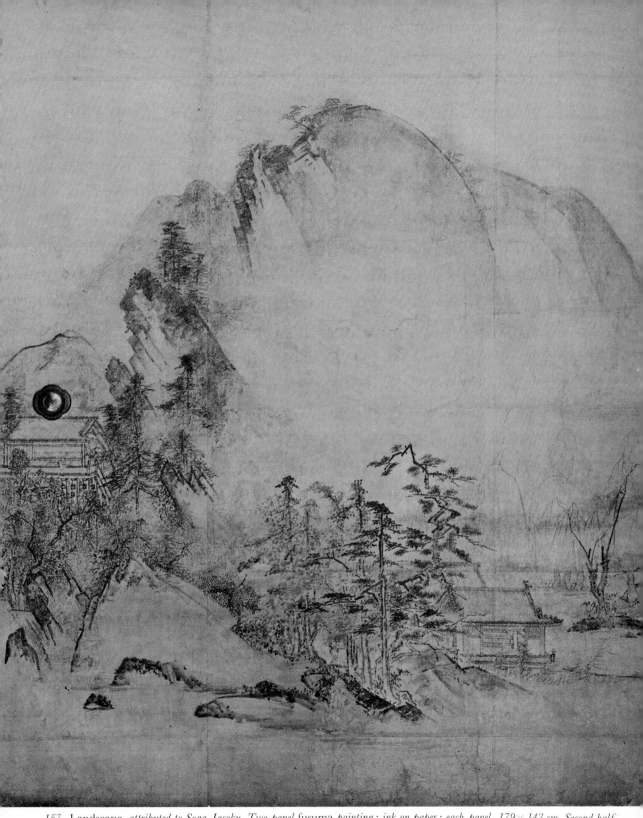

157. Landscape, *attributed to Soga Jasoku. Two-panel* fusuma *painting; ink on paper; each panel, 179×143 cm. Second half of fifteenth century. Shinju-an, Daitoku-ji, Kyoto.*

158. Detail of Chinese Lions, *by Kano Eitoku. Folding screen; colors on gold ground; 225×459.5 cm. 1582–90. Imperial Household Collection.*

159. *Detail of* Flowers and Birds, *by Kano Eitoku.* Fusuma *painting; ink on paper; 177 × 143.5 cm. 1566. Juko-in, Daitoku-ji, Kyoto.*

160. *Detail of* Pine and Autumn Grasses, *by Hasegawa Tohaku. Folding screen; colors on gold-leaf ground; each panel, 331 × 226.5 cm. C. 1592. Chishaku-in, Kyoto.*

161. Detail of Hikone Screen. Colors
on gold-leaf ground; each panel, 94 ×
48 cm. C. 1630. Ii Collection, Shiga
Prefecture.

162. Detail of Yamanaka Tokiwa Picture Scroll, attributed to Iwasa Matabei. Colors on paper; height, 34.2 cm. First half of seventeenth century. Atami Art Museum, Kanagawa Prefecture.

163. Detail of Hozu River, *by Maruyama Okyo. Folding screen; colors on paper; 155×497 cm. 1795. Nishimura Collection, Kyoto.*

164. True View of Mount Asama, *by Ikeno Taiga. Colors on paper; 57 ×
102.7 cm. 1750. Kuribayashi Collection, Tokyo.*

雪簇東西
南妨嶺
烟披十萬
八千嶌
奉似
龍門祗園先生
平安池舟名

165. The Summit of Mount Fuji, *by Tomioka Tessai. Folding screen; colors on paper; 154.5×359.5 cm. 1903. Seicho-ji,*
Hyogo Prefecture.

166. Kajikazawa in Kai Province, *from* Thirty-six Views of Mount Fuji, *by Katsushika Hokusai. Woodblock print; 26 × 38 cm. C. 1830. Takahashi Collection, Tokyo.*

167. The Bridge at Uji. *Folding screen; colors on gold ground; 145 × 318 cm. First half of seventeenth century. Tokyo National Museum.*

Motonobu adopted Ming (1368–1644) techniques. He had no objection to realistic brushwork, and painted birds and flowers, rocks and trees with fidelity, even adding touches of color. His interest naturally lay in things rather than space, and in achieving a strong and direct realism rather than an abstract atmosphere. Consequently the works of Motonobu and the Kano school may seem heavy when compared with those of great artists like Unkoku Togan and Hasegawa Tohaku, who followed the mainstream of the *suibokuga* tradition, painting pure forms with fresh, clear brushwork. Rather than heaviness, the Kano style might better be said to be characterized by a persistent syncretism, and this is in fact its strength.

The Kano school lightheartedly approached the stolid painting of the Tosa school, with its detailed, brightly colored representation of birds, flowers, and other natural objects, borrowing its color schemes and naturalism. At the same time, this opened up the possibility of also adopting its decorative character. The Kano school has been labeled eclectic. Motonobu, and the later Eitoku and Sanraku as well, were self-aware artists, and though their styles were wide-ranging, their attitude cannot be characterized by the vague term eclecticism. Inasmuch as the Kano school added color to a typically *kanga*-style structure of spatial perspective and a three-dimensional framework for objects, its style is quite distinct.

Painters of the Tosa school, although striving for emotional effect through fine line and sensuous coloration in the *yamato-e* tradition, lacked clarity of vision. More interesting are the anonymous artists, not members of any particular school, who were vigilantly watching for a chance to show what they could do in the new age. Their creativity is to be seen in such anonymous, boldly designed decorative works as the *Sun and Moon* screens or the *Bridge at Uji* screens (Fig. 167), and in textile designs and pictures on folding fans. Screens with a ground of gold leaf were among the wares exported to China by the shogun Ashikaga Yoshimitsu (r. 1368–94), and with the added sophistication of the sun, moon,

168. Detail of Juraku-dai. *Folding screen; colors on gold ground; 156×302 cm. Late sixteenth century. Mitsui Collection, Tokyo.*

mist, and stream motifs painted on them, the way was paved for the brilliant gold-screen painting of the Momoyama period.

Perhaps the first things that come to mind in connection with the art of the brief but brilliant Momoyama period are the gorgeous screen paintings and castle decorations. The latter half of the sixteenth century was a period of continuous warfare from which three men—Oda Nobunaga, Toyotomi Hideyoshi, and Tokugawa Ieyasu—emerged in turn as victorious unifiers of Japan. Amid the general destruction, castles were built for the protection of feudal lords and their heavily armed standing armies, and these became the symbol of the time. The castles constructed by the three great generals—Azuchi, Fushimi, Juraku-dai, Osaka, Edo—grew ever larger in scale. Like those of sixteenth- and seventeenth-century Europe, they were fortresses, with stone walls as a defense against

cannon fire and surrounded by a moat. They also served as a palace and an administrative center, housing offices and living quarters for large numbers of people. When one climbs to the top of a castle donjon and looks down at the rows of houses and network of canals outside the moat, or the fields and rivers in the distance, one can begin to imagine the rich inventiveness of this age in which feudal lords struggled with each other over the accumulation of territory and the development of a new social structure.

Azuchi Castle, built by Oda Nobunaga in 1576 on the southwest coast of Lake Biwa, was a magnificent structure. Nobunaga must have been greatly pleased with it, since we know that he invited Portuguese missionaries to inspect it, and even presented them with a screen on which the castle was faithfully depicted. He is said to have even opened it to the local populace at New Year. Since

169. *Detail of* Rakuchu Rakugai *(Scenes in and around Kyoto), by Kano Eitoku. Folding screen; colors on gold ground; 159.4 ×*
363.3 cm. C. 1574. Uesugi Collection, Yamagata Prefecture.

the castle itself was designed to symbolize Nobu-
naga's political ideals, he commissioned Kano Ei-
toku (1543–90) to decorate the seven-story donjon
with magnificent paintings on gold screens and wall
panels. Eitoku was the perfect choice for the proj-
ect, since his ink paintings on the sliding doors of
the Juko-in, Kyoto (Fig. 159), had already revealed
his powerful sense of design and line.

Nobunaga and Eitoku must have got along
together very well. The paintings that Eitoku
executed at Azuchi Castle were lost with the
destruction of the castle soon after Nobunaga's
death in 1582, but their content is recorded in the
Nobunaga Koki (Nobunaga's Life). On the second,
third, and fourth floors there were representations
of Confucian and Taoist sages, as well as rooms
decorated with plum, pine, and bamboo motifs,
and others with paintings of rock, dragon-and-
tiger, phoenix, bird-and-flower, pigeon, goose, and

pheasant themes. There were no paintings on the
fifth floor, but the octagonal sixth floor contained
paintings of Sakyamuni preaching and the Ten
Great Disciples inside, while hungry ghosts were
represented on the outside. The seventh floor con-
tained paintings of the eight legendary, exemplary
rulers of ancient China, the ten Confucian philoso-
phers, the Four Sages of Shang-san, and the Seven
Sages of the Bamboo Grove. Nobunaga's own edu-
cational and cultural policies were clearly reflected
in these works.

Although Nobunaga burned the temples of
Mount Hiei, attacked the stronghold of the warlike
monks at Ishiyama-dera near Lake Biwa, and
suppressed the Lotus Sutra sects of Kyoto, as a
Buddhist himself he had images of Sakyamuni
painted for his personal worship. Systematically
filling the top story of the keep with Confucian
figures served first to identify the castle as a political

170. Birds and Flowers, *by Kano Motonobu.* Fusuma *painting; colors on paper; 178×118 cm. First half of sixteenth century. Daisen-in, Daitoku-ji, Kyoto Prefecture.*

171. Cypress, *attributed to Kano Eitoku. Folding screen; colors on gold ground; 170×462.5 cm. Second half of sixteenth century. Tokyo National Museum.*

palace and to reaffirm the old tradition of paintings of the Chinese sages on sliding doors. Secondly, it served to demonstrate Nobunaga's faith in the Confucian ideal of government. The top story is the watchtower, but it probably doubled as his study and meditation room. The educational policy of the later Edo government, based systematically on the rational political ethics of Confucianism, may well have been inspired by Nobunaga's views. Following the tastes and tradition of the Ashikaga shoguns, Nobunaga also enjoyed the Noh drama and frequently performed the tea ceremony. He must also have had an appreciation for popular culture and common people. Apart from opening his castle to the people of Azuchi when it was completed, he had Eitoku paint a *Rakuchu Rakugai* (Scenes in and around Kyoto) screen illustrating street scenes in the capital (Fig. 169), thus lending momentum to the newly popular genre painting.

Ignoring the leading *kanga*-style painters of the Muromachi period, Eitoku set the style of the Momoyama period. Although his paintings in the Azuchi, Osaka, and Juraku-dai castles no longer exist, we can imagine what they were like by comparison with the *fusuma* paintings in the Juko-in (Fig. 159), the *Chinese Lions* screen (Fig. 158), and the paintings of two other Kanos, Motonobu and Sanraku.

At the center of these compositions is often the trunk of a great pine or plum tree with branches spreading out to left and right, painted with a rough straw brush. This huge tree symbolizes heroic personality, and dominates not only the picture but the entire room. Eitoku must have painted many such "great tree trunks," and surely the tree-trunk compositions in the Daikaku-ji and the Chishaku-in (Fig. 160) reflect his influence. The device of using the trunk of a great tree as the compositional pivot of a flower-and-bird screen had already been seen in such paintings as Sesshu's *Flowers and Birds of the Four Seasons* screens and Motonobu's *fusuma* paintings (Fig. 170). Eitoku exaggerated the tree trunk, treating it like a giant's body and investing it with symbolic attributes of determination, activism, or intellect. In his paintings at Azuchi Castle he must have intended to represent Nobunaga's personality,

and when he painted at Juraku-dai he probably had Toyotomi Hideyoshi in mind.

With what emotions did the artists invest the great trees in such paintings as Sanraku's *Plum*, or the *Maple* and *Cherry* in the Chishaku-in, or the *Pine and Autumn Grasses* by Tohaku (Fig. 160)? Sanraku's *Plum* may recall someone who has performed virtuous deeds in the face of adversity; in the *Maple* we may feel a mature passion, in the *Cherry* a youthful sentimentalism and love of literature, in the *Pine and Autumn Grasses* a lucid intelligence.

In the *fusuma* painting *Twenty-four Paragons of Filial Piety* in the Nanzen-ji, Kyoto (Fig. 172), attributed to Eitoku, the Confucian characters are depicted affectionately, with nimble, delicate brushwork. Again, in the *Rakuchu Rakugai* painting, the movement with which the lives of thousands of people from all social classes are depicted is fascinating. However, both Eitoku and his contemporaries are surprisingly reticent when it comes to revealing their own personalities through the representation of human figures. They do not assert themselves in large-scale paintings of human figures, but instead express their feelings more subtly through their depiction of trees, flowers, and birds.

Peonies (Fig. 173) was painted by Eitoku's adopted son Sanraku. The peony symbolized wealth, honor, and good fortune, thus well fulfilling the function of bird-and-flower *fusuma* painting of buoying up the spirits of the people who played out the rituals of life in front of them. Pine, bamboo, and plum, cockerel, pheasant, and butterfly—all are symbols of happiness and good fortune, and at the same time function as the basic elements of new, naturalistic designs.

Sculpture had relinquished its role as a vehicle of human thought and feeling to the performers of Noh drama when creative Buddhist sculpture ceased to be produced. Instead, it had developed into decorative colored relief carving of flowers and birds. This and the Momoyama-period murals on a gold ground throb with the pulse of human feeling, not because human beings are depicted in them, as in Western painting, but because the

172. Twenty-four Paragons of Filial Piety, *attributed to Kano Eitoku.* Fusuma *painting; colors on gold ground; each panel, 184×98 cm. Second half of sixteenth century. Nanzen-ji, Kyoto.*

painters and carvers unstintingly expressed their humanity through birds and plants.

Paintings of flowers and trees bearing such human emotion must have robust forms with a certain depth, like those of sculpture. Eitoku sees his objects three-dimensionally; his painting of a cypress (Fig. 171) has an imposing sense of weight and mass. His methods are similar to those he had already used in his *fusuma* painting at the Juko-in. The keynote is modulation of tone, giving volume to the objects. The white of the paper is allowed to show through where highlights are needed. Outline shading was always executed after considering highlights. Gold dust was also used for highlighting. The techniques for representing volume and space executed in such detail in the later *Hozu River* screen by Maruyama Okyo (Fig. 163), are already present here in beautifully stylized form. Eitoku inherited Motonobu's style, exaggerated its expressionism, and built it up into a kind of baroque style expressing the heroic vigor of his age.

Another aspect of the Kano tradition that must not be forgotten is the realism of artists like Motonobu and Eitoku and their ability to respond to the practical requirements of society. Many large, beautifully colored genre paintings (Fig. 161) and the so-called *namban* screens depicting Europeans in Japan were produced by the school of artists who gathered around such pupils of Motonobu as Eitoku, Sanraku, and Tan'yu. Artists educated in the multifaceted training of the Kano tradition also turned their brushes to themes treated earlier by the narrative-scroll painters—the everyday life of common people, their foibles, amusements, afflictions, and pleasures. They even tried to assimilate the European conventions of painting taught them by Portuguese and Spanish missionaries.

Eitoku's great style was continued by his adopted

173. Peonies, *by Kano Sanraku.* Fusuma *painting; colors on gold ground; each panel, 184.2 × 99 cm. First half of seventeenth century. Daikaku-ji, Kyoto.*

son Sanraku in the large ornamental paintings of an age of peace. Eitoku's grandson Tan'yu became the official painter of the ruling Tokugawa house and was the founder of Kano academicism. In the systematic education of successors, in Kano Eino's compilation of the history and theory of painting, the Kanos are as noted for their role as art educators as for their individual achievements.

Kano Hogai and Hashimoto Gaho, who in the early years of the Meiji era tried to develop a new Japanese painting assimilating the naturalism of Western painting, were the last painters of the Kano school.

DURING THE EDO PERIOD temples declined as the leading instigators of the creation of art. Secular forces, military, political, or commercial, now dominated the production of art. From this time onward, Buddhist painting and architecture would be influenced by secular art, rather than the other way around.

Secular society in the Edo period (1603–1868) was composed of several clearly defined groups: the samurai bureaucracy, wielding political power; the wealthy merchants, who had no political responsibilities; a middle class consisting of farmers; and the urban commoners. Subsequently the samurai bureaucracy and the commoners were to form an intellectual class. To this class variety was added the major geographical and cultural differences in environment and tradition between eastern and western Japan—between the new capital at Edo (present-day Tokyo) on the one hand and Kyoto and Osaka on the other. Finally, local secondary variations added further to the complexity of Edo-period society. An unprecedented number of schools of painting flourished during this period as a result of this variety. A firm foundation

174. Detail of Enjoying the Cool Air under a Bottle Gourd Trellis, *by Kusumi Morikage. Colors on folding screen; 151.3× 168 cm. Second half of seventeenth century. Aso Collection, Fukuoka Prefecture.*

for the many schools was provided, however, by the systematic academicism of the Kano school, serving the households of the shogun and the various daimyo. This industrious, scholarly, and bureaucratic painting tradition was permeated with Confucian thought, which seems to hover in the background of the many decorative paintings of birds and flowers, animals, and landscapes. On the other hand, many wealthy merchants, barred from political activities, welcomed the fashion for so-called national studies (*kokugaku*), which attempted to revive native cultural traditions. Decorative painting in the *yamato-e* tradition made a magnificent comeback, and creative artists like Hon'ami Koetsu, Tawaraya Sotatsu, and Ogata Korin added to it a sensuous luster.

Buddhist painting of the period was associated primarily with the Pure Land sects. Also, partly because of the worldly quality of the age, partly because many leading painters were adherents of sects based on the *Lotus Sutra,* a number of great paintings were done on the theme of the Buddha's entry into nirvana. It is interesting to contrast this with the positive realism of seventeenth-century European Catholic painting. But the mainstream of European academic painting is represented by idealism, which treated didactic themes from classical mythology or ancient history, and so resembles the *fusuma* paintings of the Momoyama and Edo periods with their Confucian themes. Although genre painting and paintings of flowers, birds, and still life arise in both traditions, in Japan the flower-and-bird theme is far more common than in Europe and there are surprisingly few idealistic figure paintings. It is sad to reflect that Japan has virtually no paintings in the manner of the great portraits of the monarchs, lords, and courtiers of seventeenth- and eighteenth-century Europe.

175. Beauty Looking over Her Shoulder, *by Hishikawa Moronobu. Colors on silk; 63×31.2 cm. Seventeenth century. Tokyo National Museum.*

LITERATI PAINTING Individualistic artists like
Iwasa Matabei (Fig. 162),
Kusumi Morikage (Fig. 174), and Maruyama
Okyo (Fig. 163) established their identities as
deviants from the Kano tradition. At the same
time there developed the genre known as *bunjinga*,
or literati painting, whose painters pursued ideal-
ism and personal freedom in art, in opposition to
the Kano academicism.

With the popularity of Chinese studies in the
mid-Edo period, Ming and Ch'ing (1644–1912)
bunjinga were esteemed among people of classical
education. Japanese painters in the *bunjinga* style,
such as Ikeno Taiga, Yosa Buson, Aoki Mokubei,
Uragami Gyokudo, and Tanomura Chikuden, were
respected as intellectual painters not only in the
art centers of Kyoto, Osaka, and Edo but through-
out the country.

Avoiding obsessive naturalism, these artists
sought to express the essential nature of ink paint-
ing, with its lively line and modulated tones. Their
work is the fruit of an educated mentality. While
Gyokudo expressed his feelings with charming
brushwork in ink of unusual colors, Taiga produced
one large, richly conceived painting after another,
and with his bold creative powers laid bare the
heart of classically educated man. In his landscapes
from nature he exercised his keen powers of obser-
vation rigorously, even adopting Western perspec-
tive (Fig. 164). Tomioka Tessai, a prolific and
highly individual painter, continued this tradition
well into the modern period, finding elements in the
tradition that were similar to the art of the Fauvists
and expressionists in the West (Fig. 165).

UKIYO-E PRINTS The rich and varied history of
ukiyo-e prints stretches from
Hishikawa Moronobu (?1625–94) to Katsushika
Hokusai (1760–1849) and on into the modern
period. Moronobu, whose style (Fig. 175) devel-
oped from that of Iwasa Matabei (Fig. 162), was

the forefather of the ukiyo-e prints of Edo. Hokusai,
the last great ukiyo-e master, in the early nine-
teenth century produced forty-six prints in a series
with the title *Thirty-six Views of Mount Fuji* (Fig.
166), opening a new path for ukiyo-e landscape
prints. These new landscape prints had as their
framework the spatial construction of Western
perspective but did not adopt the method of Dutch
prints for modulating tone. The development of
these colored prints was a revolutionary event.

Hokusai, who had studied under Kano painters,
had mastered the analytical observation of objects.
The keen, exploratory line of his prints catches the
lively movements of human figures in all manner
of guises and postures, as well as the varied world
of nature. Beyond the revolutionary changes he
brought about in ukiyo-e, Hokusai's prints, to-
gether with Ando Hiroshige's landscape prints (Fig.

176. Shono, *from* The Fifty-three Stations on the Tokaido, *by Ando Hiroshige. Woodblock print;* 24 × 37 cm. 1833.

176), had an eye-opening effect on the French impressionist painters, thus playing a role in the development of modern painting.

THE HISTORY OF JAPANESE ART is punctuated by periods of direct continental influence. Korean and Chinese influences are apparent from prehistoric times and continued to enter Japan for centuries. The Japanese have traditionally looked up to the cultural colossus that was China, for it was this great civilization that had brought Japan a writing system, art, ethics and philosophy, and had transmitted Buddhism as well. A survey of Japanese history is incomplete without a discussion of the overwhelming Chinese influence in Japanese art. As mentioned at the very beginning of this book, however, I have attempted to go beyond this to trace the influence of countries west of China.

China had early trade links with ancient Greece, Rome, and Parthian and Sassanian Persia. The cultures of these civilizations slowly found their way into Chinese life and art. And these cultural traits were eventually transmitted to Japan in their Sinicized forms.

Japanese art as a whole may be viewed as evolving within the context of alternating waves of influence from abroad and periods of internal consolidation and development. But through this undulating rhythm runs an underlying quality that sets Japanese art apart from its foreign models—a quality that surfaces vigorously from time to time. Even when it is quiescent, it continues to serve as a catalyst determining the manner in which every strain of foreign influence is assimilated and integrated so that it contributes to the unique culture of Japan.

TITLES IN THE SERIES

Although the individual books in the series are designed as self-contained units, so that readers may choose subjects according to their personal interests, the series itself constitutes a full survey of Japanese art and will be of increasing reference value as it progresses. The following titles are listed in the same order, roughly chronological, as those of the original Japanese editions. Those marked with an asterisk (*) have already been published or will appear shortly. It is planned to complete the English-language series in 1976.

The "weathermark" identifies this book as a production of John Weatherhill, Inc., publishers of fine books on Asia and the Pacific. Supervising editors: Suzanne Trumbull and Akito Miyamoto. Book design and typography: Meredith Weatherby. Layout of illustrations: Akito Miyamoto. Production supervision: Yutaka Shimoji. Composition: General Printing Co., Yokohama. Engraving and printing of color plates: Mitsumura Printing Co., Tokyo, and Benrido Printing Co., Kyoto. Monochrome letterpress platemaking and printing and text printing: Toyo Printing Co., Tokyo. Binding: Makoto Binderies, Tokyo. The typeface used is Monotype Baskerville, with hand-set Optima for display.